THE BROADS
THROUGH TIME
David Holmes

AMBERLEY PUBLISHING

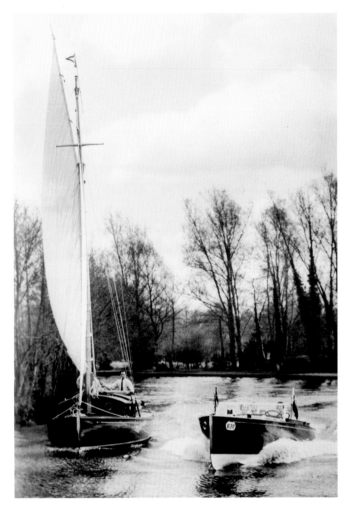

River traffic: on the Bure near Wroxham, 1955.

First published 2009

Amberley Publishing Plc
Cirencester Road, Chalford,
Stroud, Gloucestershire, GL6 8PE

www.amberley-books.com

Copyright © David Holmes, 2009

The right of David Holmes to be identified as the
Author of this work has been asserted in accordance
with the Copyrights, Designs and Patents Act 1988.

ISBN 978 1 84868 642 7

British Library Cataloguing in Publication Data.
A catalogue record for this book is available from
the British Library.

Typeset in 9.5pt on 12pt Celeste.
Typesetting by Amberley Publishing.
Printed in the UK.

Introduction

In 1960, it was proved conclusively that the Broads are a man-made system of shallow lakes, the result of medieval peat digging in an area that had once been impenetrable swampland. With this knowledge came the realisation that the area is uniquely a cultural landscape rather than a natural one. The rivers, which in their natural state would have been shallow, weed-choked channels, had all been widened, straightened and deepened to form a navigable transport system across the marshy flood plain. Even the marshes surrounding the Broads and rivers are not entirely natural habitats. They had been created by embanking and drainage, and preserved by centuries of seasonal harvests of hay, reed and sedge. The gaunt remains of drainage windmills, no longer fulfilling their original function, serve as reminders of an era of intensive management of these wide open flatlands.

The Victorians opened up the Broads, as railways brought new visitors, and town dwellers discovered the romance of boating on safe lock-free waterways. The traditional sailing craft of the Broads, the Norfolk wherry, was modified for a new trade, holiday revellers taking the place of coal, timber and barley. Soon, an entirely new fleet of pleasure craft was built, and the Broads holiday became an established feature of the British summer. Diesel engines displaced steam power and sailboats were only for the minority. Waterside facilities were developed for the tourists, and department stores appeared in the most unlikely places, most famously in Wroxham, where Roys laid claim to be 'the world's largest village store'.

Despite the bustle of busy waterways and the commercial exploitation of the Broads, the area also developed a well-deserved reputation for pioneering nature conservation in protected marshland sanctuaries. The most enigmatic of wetland birds, the bittern, still breeds deep in the reed beds, its booming calls echoing across the marshes just before the Easter dawn. In the summer sunshine of a June day, the

riverside flowers are enlivened by Britain's most impressive butterfly: the swallowtail. At all seasons, the marshes are quartered by the marsh harrier, an opportunist raptor which has increased its numbers beyond all expectation in recent years. Most encouraging of all, the otter, almost extinct a decade ago, is now regularly seen throughout the Broads, and has established new territories in the quieter rivers.

The seasons are more marked in the Broads than in most areas. Even the thinnest ice stops most boating activity, so rivers busy in summer are reclaimed by the grebes and wildfowl in winter. The reed harvest, still an important economic activity in the area, has to wait until the first harsh frosts strip the leaves and fleshier plants away from the crop. Traditionally, the reed harvest starts on Boxing Day, but it is over by Easter because the new shoots of next year's reed start to appear and cutting has to stop. In some parts of the Broads, sedge, a tall, strap-like marsh grass, is also cut for the thatchers, and this is strictly a summer harvest. The sound of the marshman scything through the lush growth of summer sedge is one of the secret delights of the Broads experience, and yet, this marshland world is barely two hours from the crush of London traffic.

Any attempt to take photographs to match the exact location of old monochrome images (which, by the way, almost entirely derive from my own collection) was bound to be frustrating. Riverbanks have eroded, roads have been realigned, waterside staithes, which were once public, are now, for one reason or another, inaccessible private preserves. Above all, trees have grown rampantly throughout the Broads district, to the detriment of the landscape, blocking views, reducing precious marshland wildlife habitats and minimising effective sailing opportunities. Often, it is physically dangerous to undertake photography: there is no future in capturing images from the permanently busy highway over Wroxham Bridge! I have, therefore, sometimes chosen instead to represent the changes through time by more imaginative juxtapositions of pictures. Sometimes the changes have been so far reaching that there is no point in trying to compare photographs, and yet, occasionally, places have retained their character against all the odds. Such places can still give great joy.

David Holmes

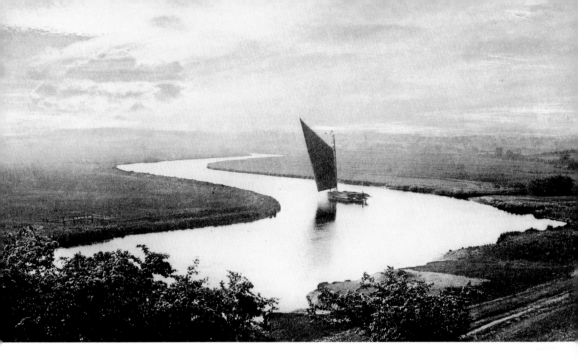

Whitlingham Vale from Postwick Grove, Looking Towards Norwich

This is one of the most enduring images of the Broads. G. Christopher Davies' famous picture, taken in 1882, of the Yare Valley from the steep river terrace at Postwick Grove, captured a view that will never be seen again. Trees have now covered the slopes and dense, bushy scrub dominates the formerly open marshland. The Norwich Southern bypass sweeps across the valley at a high level, just visible towards the right of the modern picture.

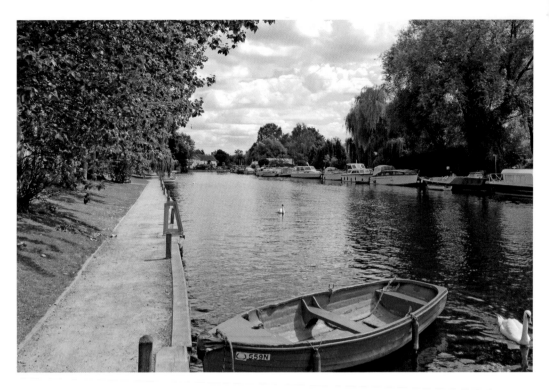

Riverside at Thorpe St Andrew

Just outside Norwich, the riverside green at Thorpe has always been a popular open space, and across the river, accessed by a rowing boat, is one of the pioneer boat-hiring yards of the Broads: G. Hart & Sons. Harts, established in 1878, built some fine craft, and around 1950, they effected a subtle but effective name change to Hearts Cruisers.

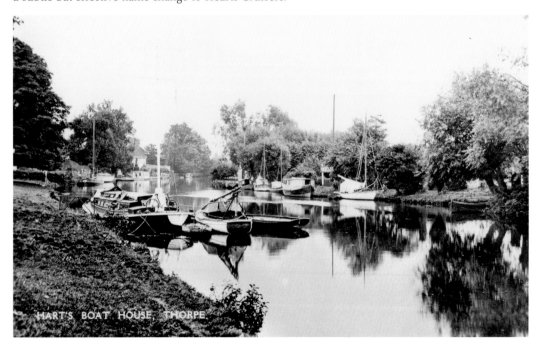

HART'S BOAT HOUSE, THORPE

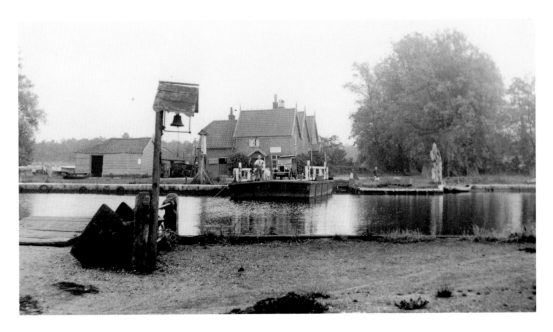

Surlingham Ferry House

These pictures are taken from the north bank of the River Yare, not far from Brundall. Surlingham ferry itself was, quaintly, requisitioned by the War Office during the Second World War, and was damaged when it broke loose one night. Despite repeated representations by Surlingham Parish Council, it was never reinstated.

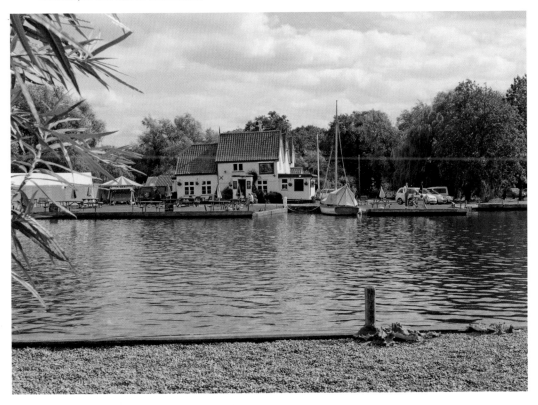

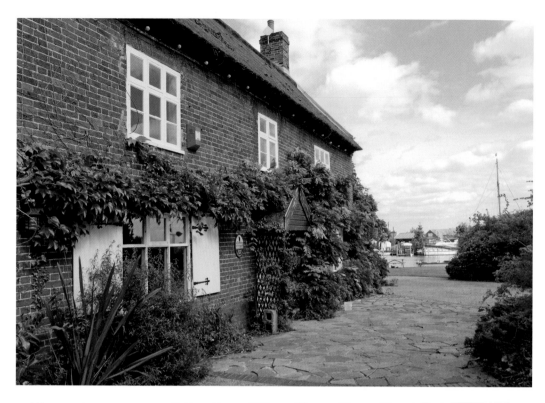

Coldham Hall

A celebrated Broadland Inn, also with its own ferry, but only for foot passengers, Coldham Hall was one of several public houses that were closed when the colour photographs were taken for this book in the summer of 2009.

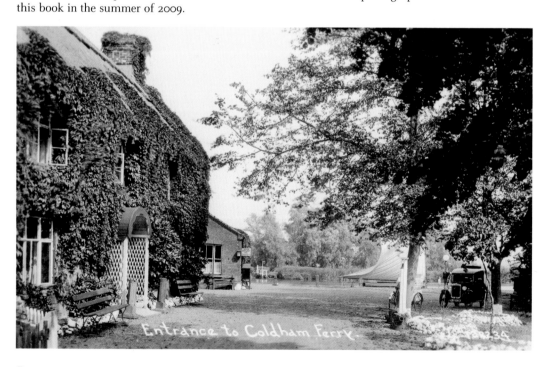

Entrance to Coldham Ferry.

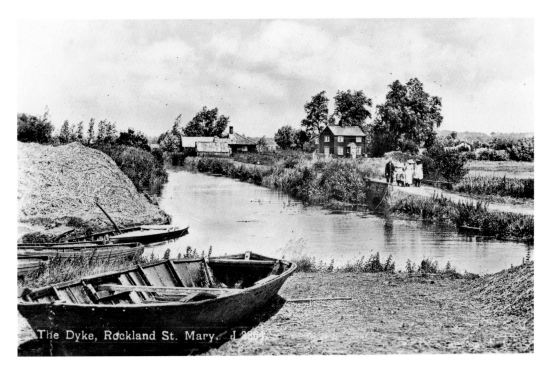

The Dyke, Rockland St. Mary.

Rockland Staithe

The Fleet Dyke leading from the River Yare to Rockland Broad and then on to Rockland Staithe was reopened to river traffic in the early 1930s after extensive dredging, and the staithe provided a convenient mooring, then as now, for the nearby New Inn. It took court action to establish that Rockland was tidal, and therefore free for public shooting and angling.

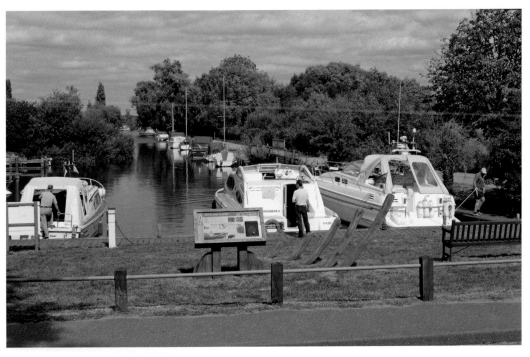

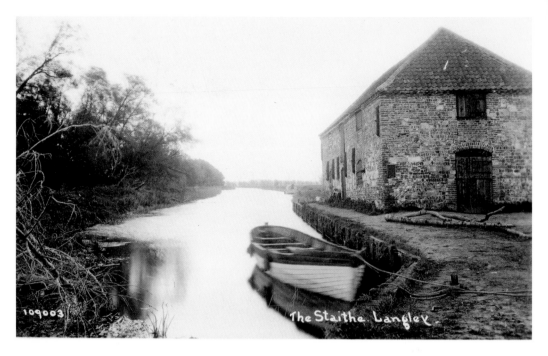

Langley Staithe

Now a quiet mooring for private craft, Langley Dyke is a straight channel that once led to a staithe, used by trading wherries to discharge cargo, especially coal, for the village and district. The warehouse has disappeared without trace.

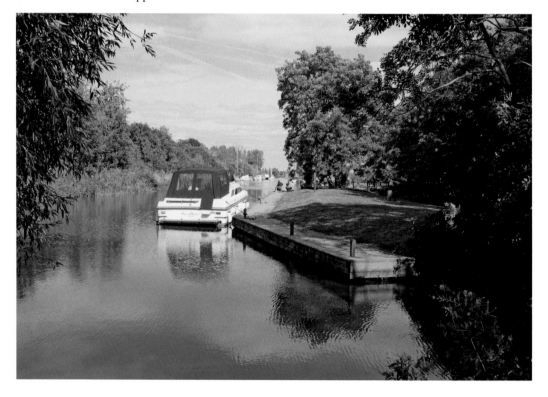

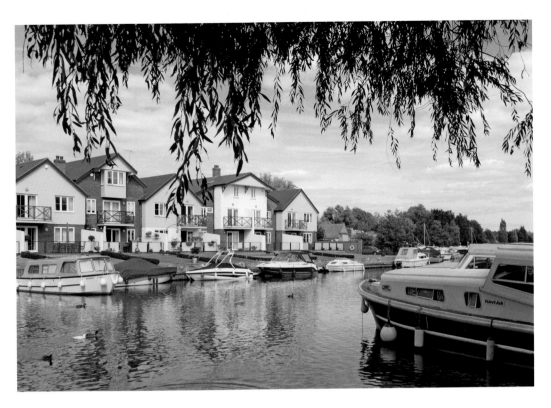

Loddon Staithe

The modern redevelopment of Loddon Staithe is tasteful and interesting but means that public access to the northern bank of the River Chet is no longer possible. The wherry shown in the older photograph, as so often, is unidentified, since wherry name-plates are only carried at the fore end.

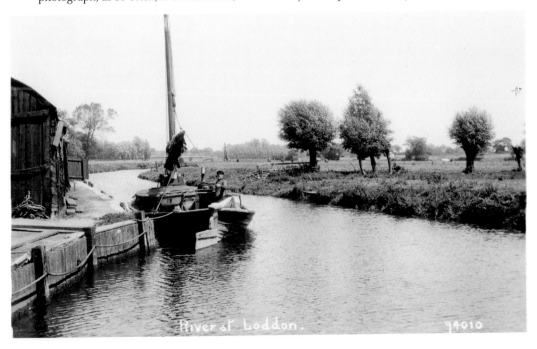

River at Loddon. 94010

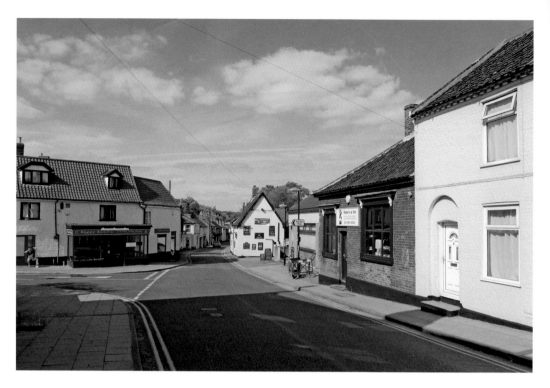

High Street, Loddon

To the left is J. B. Pryke's grocery and drapery, together with delivery van parked outside, which is now replaced by the Happy Buddha (are there any sad or depressed Buddhas?) Chinese takeaway. Loddon is one of the larger Broadland villages, and it has retained both its charm and character.

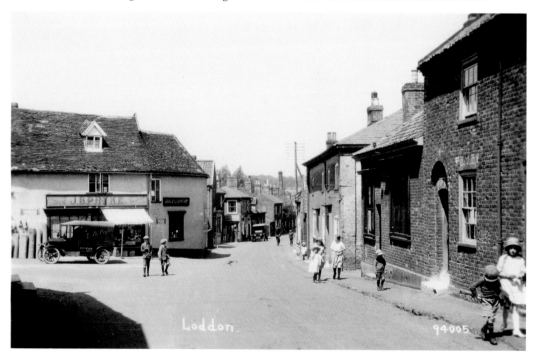

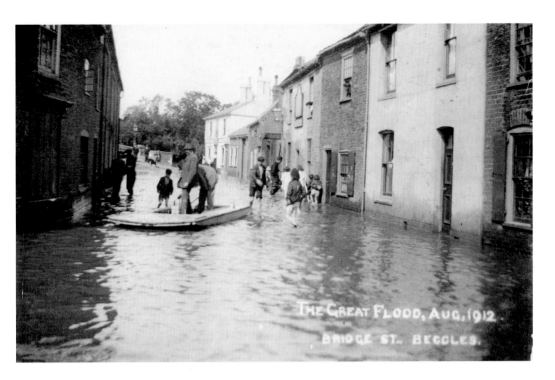

The Great Flood, Aug. 1912.
Bridge St. Beccles.

Bridge Street, Beccles

The 1912 floods hold an unrivalled status in the weather history of East Anglia. Average rain for August is a little over two inches, but in August 1912, most parts of Norfolk and Suffolk experienced torrential storms, with strong winds. The worst day was Monday 26 August, with around eight inches of rain falling in twenty-four hours. The riverside areas of Beccles were badly affected, and normal life was seriously disrupted.

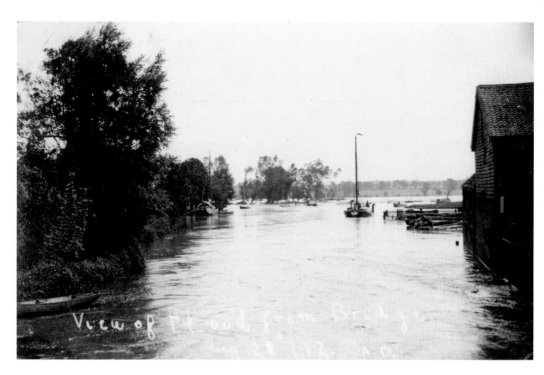

From the Bridge Over the River Waveney, Beccles
The 1912 photograph shows the extensive nature of flooding at this point, which in effect closed many businesses that, in some cases, never recovered. The tranquil modern scene provides genuine contrast, but reveals housing built ill-advisedly on an obvious floodplain.

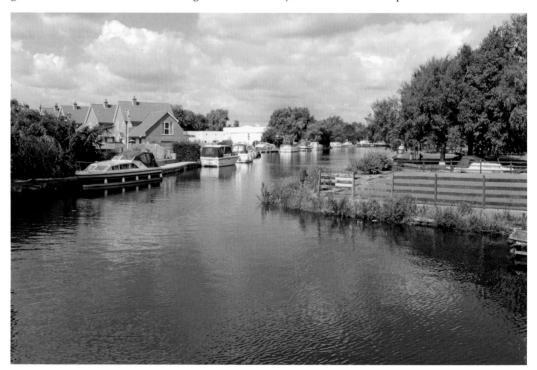

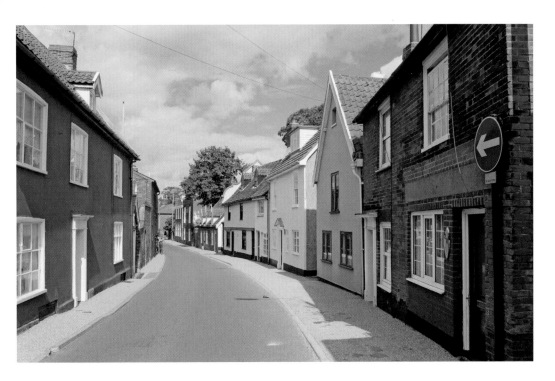

Northgate, Beccles

For years, Northgate was the main route from Norwich to the centre of Beccles, but now, it is thankfully bypassed and beautifully preserved by sensitive planning and careful private initiative. In the older picture, the regular Eastern Counties service bus number 17 is heading into town on its route from Norwich to Lowestoft – in 1955 the timetable lists fifteen services each way daily between Norwich and Beccles.

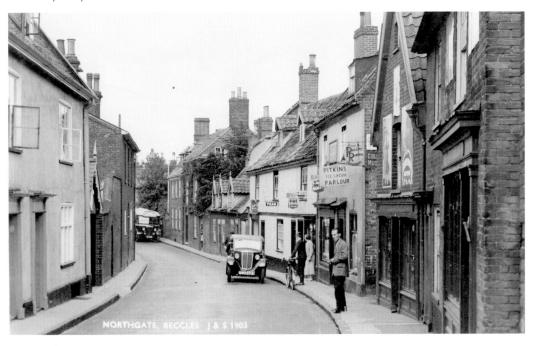

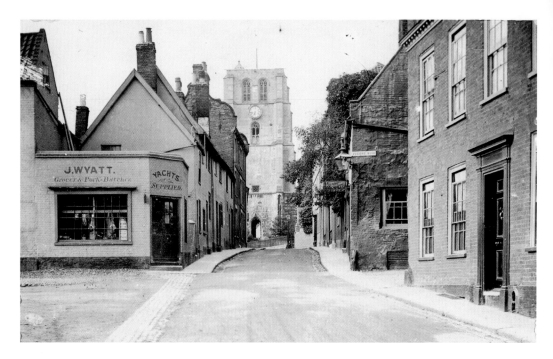

Beccles, Looking Towards the Church and Market Place

The sepia photograph was taken in the 1890s and shows Saltgate and The Walk blissfully devoid of traffic. Note that J. Wyatt, grocer and butcher, advertises that yachts are supplied, although it is quite a long trek to the river either via Pudding Moor or back down Northgate. The sixteenth-century free-standing bell tower, separate from the church of St Michael, dominates the view in both pictures.

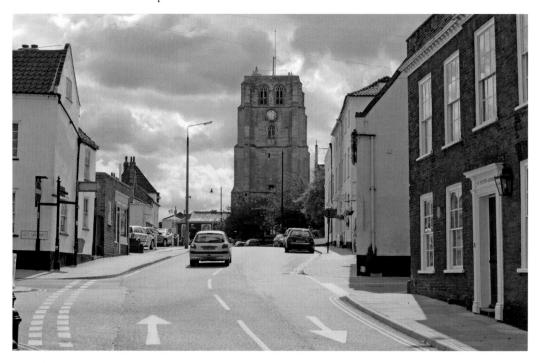

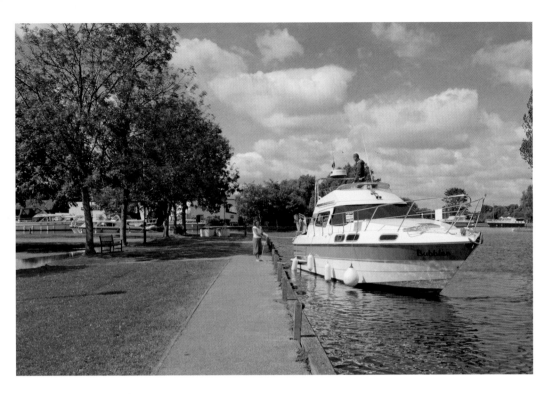

The Quay, Beccles

River craft are made very welcome at Beccles, and there is a real haven for boaters at the quay. The sepia picture dates from about 1950, and the only major change is the usual growth of trees obscuring the view. Note the wherry mast in the left of the 1950 picture – the *Albion* is visiting Beccles.

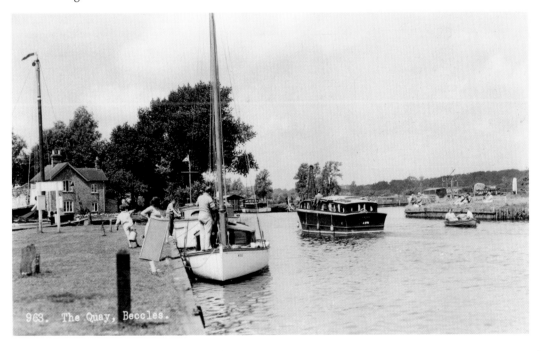

963. The Quay, Beccles.

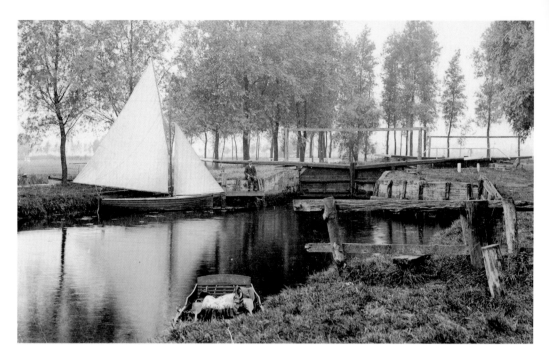

Geldeston Lock

In 1670, an Act of Parliament was passed to allow improvements to the River Waveney Navigation between Beccles and Bungay, some 7 miles. Three locks were necessary, at Wainford, Ellingham, and Geldeston. The Waveney Navigation closed in 1934 and the river now bypasses the derelict lock, but the channel is no longer navigable by anything larger than a dinghy. Geldeston is the upstream limit for all hire craft.

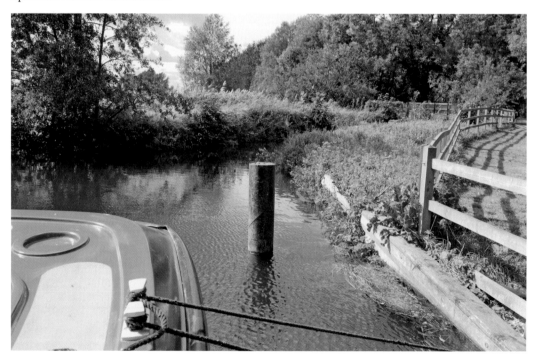

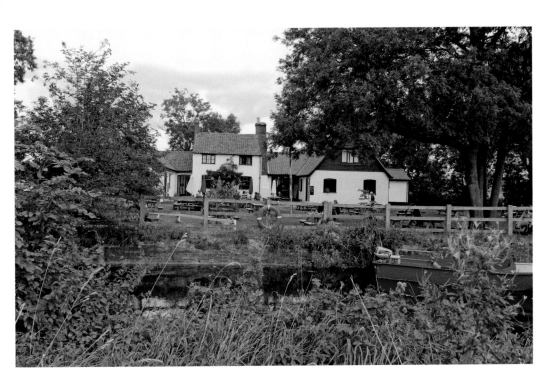

Geldeston Locks Inn

With its remote and romantic location at some distance from the highway, the Locks Inn once enjoyed a reputation for illegal activity, including prize fighting. Various eccentric characters have held the licence here, notably Susan Ellis from Londonderry, famed for her stories of ghostly apparitions, perhaps invented to boost winter trade. The inn closed at the end of the twentieth century, but is now back in business and is a celebrated Real Ale pub.

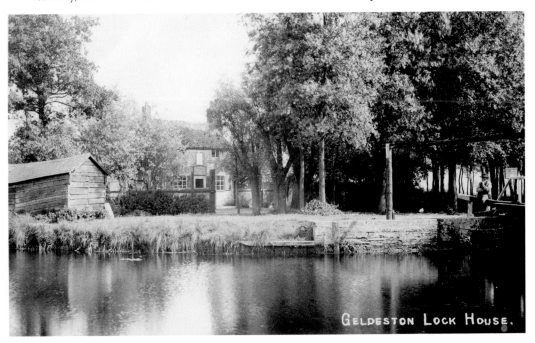

GELDESTON LOCK HOUSE.

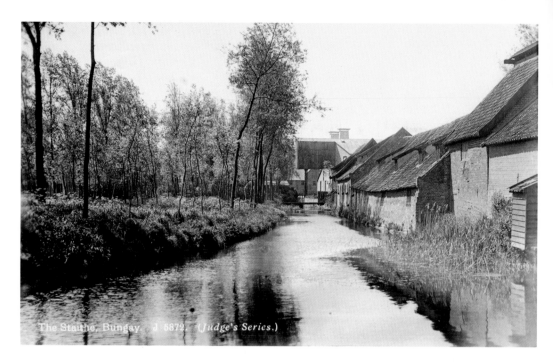

The Staithe, Bungay. J 5872. (*Judge's Series.*)

Bungay Staithe

After the Waveney Navigation closed in 1934, Bungay Staithe started its inexorable decline, and the view seen in the older photograph is now virtually unrecognisable, overgrown by reeds, bushes and trees. However, some of the old buildings have been restored as attractive private housing, and the Broads Authority projects team have made the public areas attractive and pleasant to visit. The newer photograph shows the converted watermill, which last ground corn in 1960.

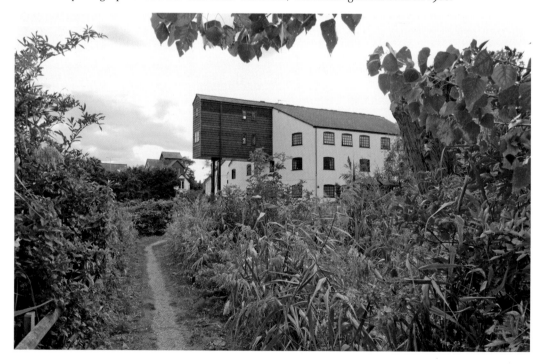

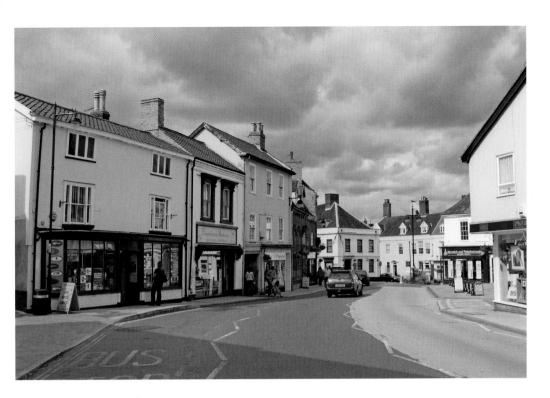

Bungay Market Place

It is pleasing to note that Bungay, one of Suffolk's most pleasant towns, has retained its character into modern times. Some hint of the change in business practice is given by the shop signs in the 1920s scene – printers, dyers, boot factory, and tailor – all unlikely uses for town centre shops in rural Suffolk today.

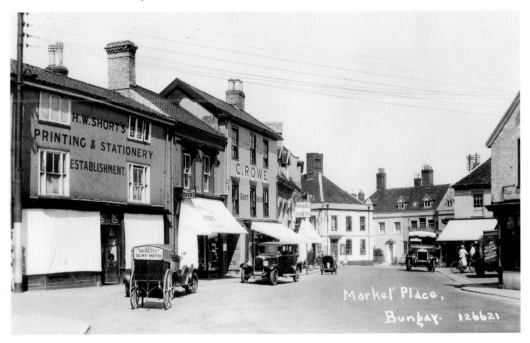

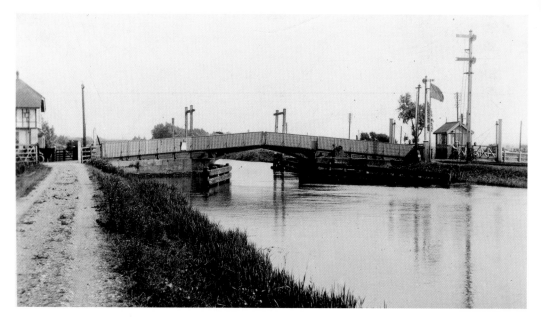

Haddiscoe Bridge

The contrasting bridges in these two photographs cross the New Cut, a canal opened in 1833 as part of William Cubitt's scheme to allow ships to sail to the port of Norwich without paying dues at Yarmouth. The older photograph shows the Queen's Head, now closed, and the two-leaf bascule lifting bridge built in 1827. The complexity of spanning both the New Cut and the railway in modern times proved challenging, but the modern bridge was completed in May 1961.

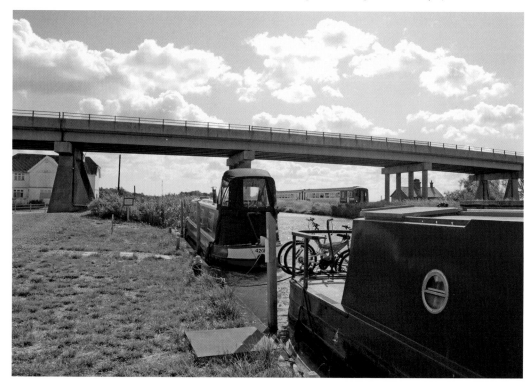

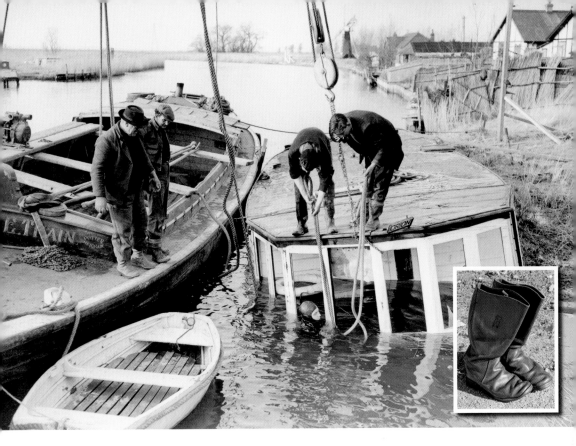

St Olaves: a Forgotten Calamity from 1956

Orion, sunk at her moorings, is being salvaged by Thains of Potter Heigham in 1956. By now, their wherry, the *Lord Roberts*, has been motorised, but not dismasted – useful for cranage. The big man supervising operations from the wherry is 'Blucher' Thain – the inset shows his boots, still preserved. St Olaves' trestle smock drainage windmill is just visible in the background of the 1956 photograph: it has now lost its sails, and is hard to find in the newer picture.

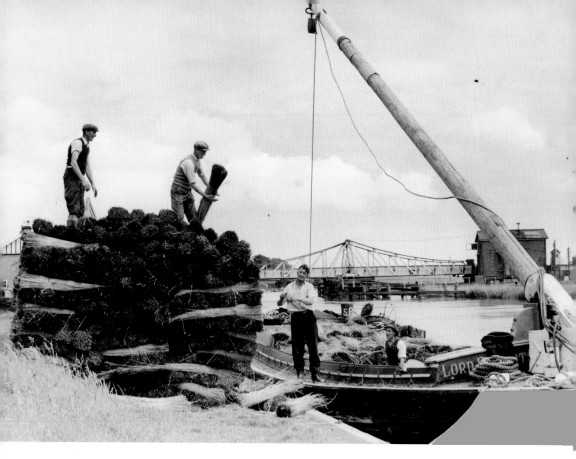

Reedham Quay, Just Upstream of The Ship Inn

The wherry *Lord Roberts* is seen performing another useful function, transporting Norfolk reed for thatching, in this view from 1958. In the background of both photographs is Reedham Railway Bridge, one of two swing bridges needed on this section of railway. This one crosses the Yare whilst the Somerleyton Bridge spans the Waveney. Both were opened in 1847 when the 11½-mile section from Lowestoft to Reedham Junction (and thus to Norwich) was completed.

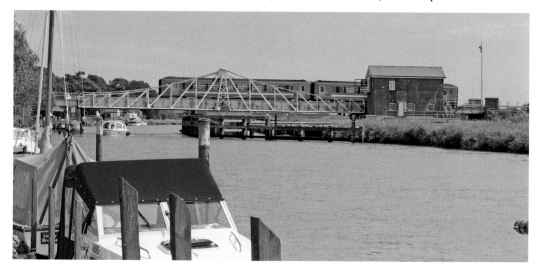

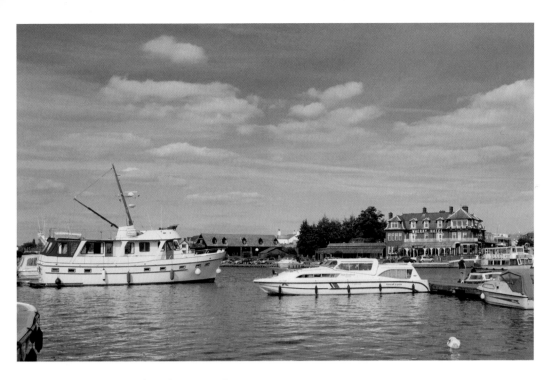

The Wherry Hotel, Oulton Broad

The Wherry Hotel is still a prominent part of the scene at Oulton Broad, although one is unlikely to see two wherries by the quayside at Oulton now. The wherry nearest the camera is the *Meteor* of Surlingham, fully laden and getting underway. Although there is a good variety of craft in the newer picture, Oulton Broad is no longer a centre for hiring holiday boats. Once second only to Wroxham, almost all the famous yards have now closed.

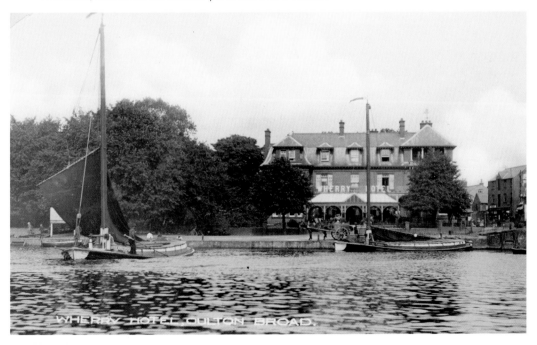

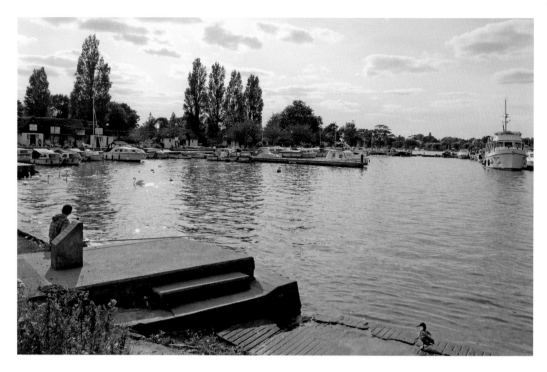

Yacht Station, Oulton Broad

The southern shore of Oulton Broad is always interesting: Nicholas Everitt Park provides an opportunity for gentle recreation; the Yacht Station always has an array of diverse craft, and the Waveney and Oulton Broad Sailing Club is based nearby. Nicholas Everitt, a local solicitor at the end of the nineteenth century, was an expert on the rights of fishing, shooting and sailing on the Broads, so it is highly appropriate that he is remembered in the name of the park.

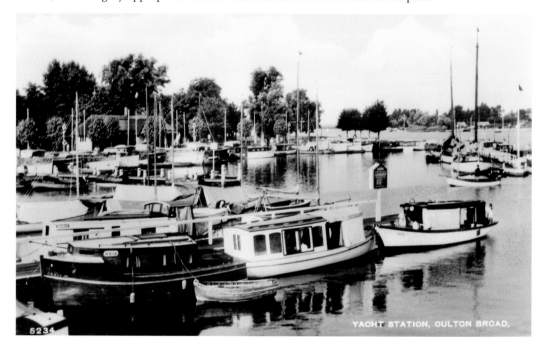

YACHT STATION, OULTON BROAD,

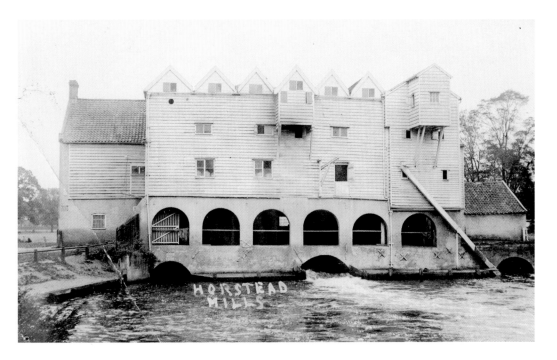

Horstead Mill on the River Bure

Both pictures are taken from almost exactly the same point, and the fundamental change in the view is the result of a major fire, in the depths of one of the coldest winters in living memory, on 23 January 1963. The mill had previously been one of the biggest watermills in Norfolk, and the last to operate on the River Bure, still grinding corn during the First World War, and producing animal feedstuffs for many years thereafter.

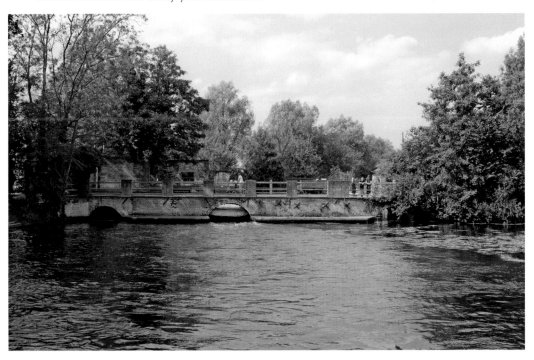

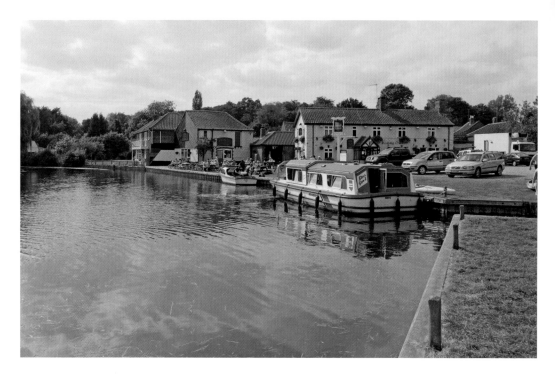

Coltishall, Rising Sun Staithe

Two flourishing pubs still co-exist side by side close to the River Bure in Coltishall, but the older photograph proves that what is now The Rising Sun was formerly part of a complex of trading stores, granary and warehouses. The wherry in the older picture is a former trading wherry converted for pleasure use: note the crew's quarters at the stern, which retain the roof line of the trading vessel.

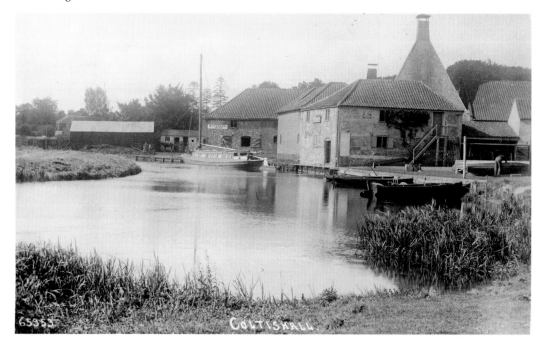

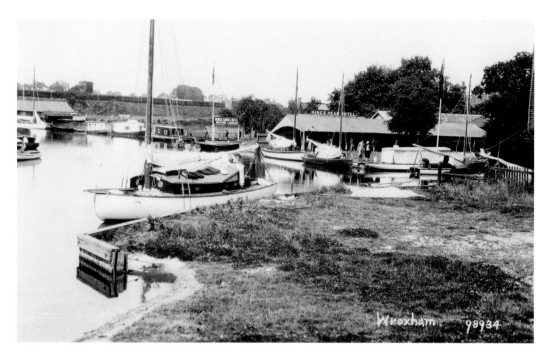

Wroxham King's Head Staithe

Upstream of Wroxham Bridge, the most obvious change between the two scenes, snapped from almost exactly the same point, is the obscuring growth of willows. As a result, the railway line is much less obvious today, although the railway bridge remains visible in the distance. The King's Head still welcomes waterborne guests, mostly by powered craft nowadays; sailing boats predominate in the older photograph.

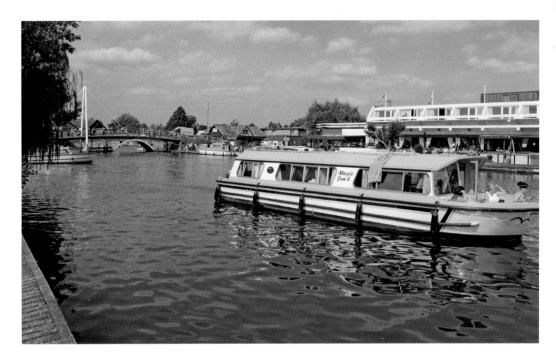

Wroxham Bridge, Downstream Side

The medieval stone bridge has survived, but almost everything else has changed. The Hotel Wroxham has taken over the site of Alfred Collins' Boatyard, the old steam mill, granary and warehouse have gone, and a stylish, new footbridge was opened in 2002. Moored on the left in the older photograph is the *Pauline*, the largest vessel ever offered for regular hire on the Broads: from 1923 to 1939, this former Thames barge offered 'Personally Conducted Tours' skippered by owner Frederick Miller.

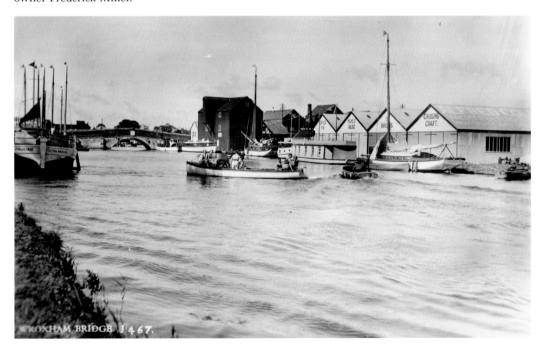

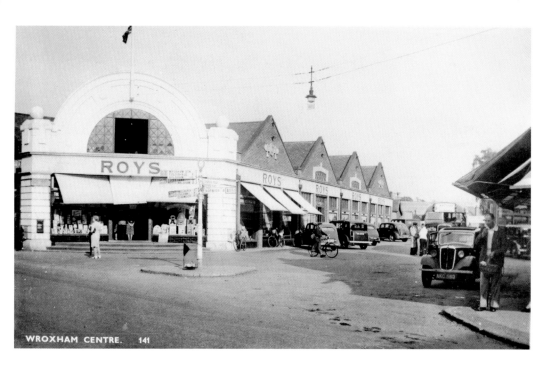

WROXHAM CENTRE. 141

Wroxham Centre – or More Accurately, Hoveton Centre

The name 'Roys of Wroxham' has ensured that the twin villages of Wroxham, south of the River Bure, and Hoveton, north of the river, are perpetually confused. Roys shops here are actually all in Hoveton: too late now to change the perception. The name of the railway station was changed, to 'Hoveton and Wroxham', in the 1980s, but this merely added to the confusion. The earlier view, from around 1947, shows one of the hanging streetlights provided by Roys for community benefit.

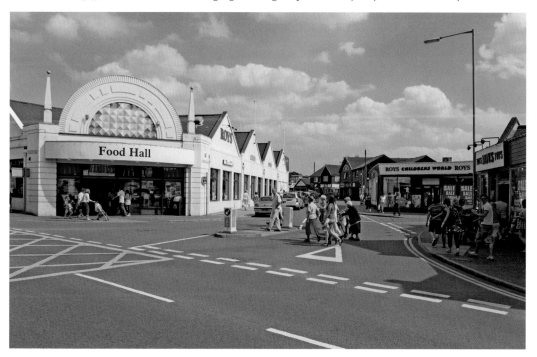

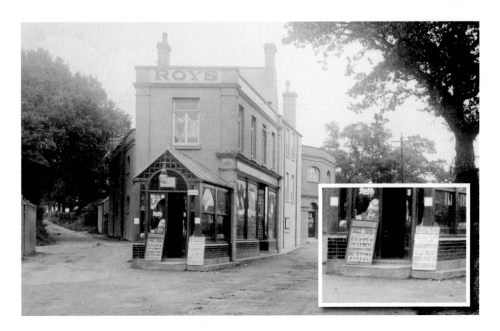

Roys Department Store, Stalham Road, Hoveton

The modern photograph shows the present store built following the disastrous fire of 1995. The old photograph is exceptional. Roys was established in Wroxham in 1899, but the Point House, shown here, was the first purpose-built brick building commissioned by the firm. Close analysis of the newspaper billboards outside the shop (see the inset), which report on one of the most celebrated trials of the century, provides an exact date for the photograph. They refer to the pre-trial committal proceedings at Bow Street, which took place on Tuesday 30 August 1910, so the picture must have been taken the next day. The 'Mr Newton' mentioned in the left-hand notice was Arthur Newton who represented Dr Crippen; Ethel Le Neve was represented by Mr J. H. Welfare. Both the accused were sent for trial at the Old Bailey, where Crippen was found guilty of the murder of his wife Cora (and was hanged on 23 November 1910), but Le Neve was cleared of the charge of 'being an accessory after the fact'.

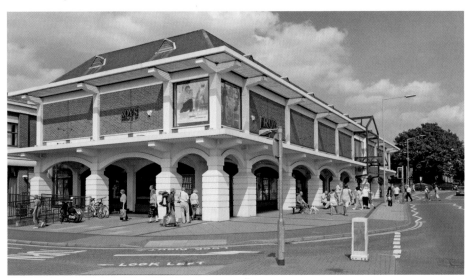

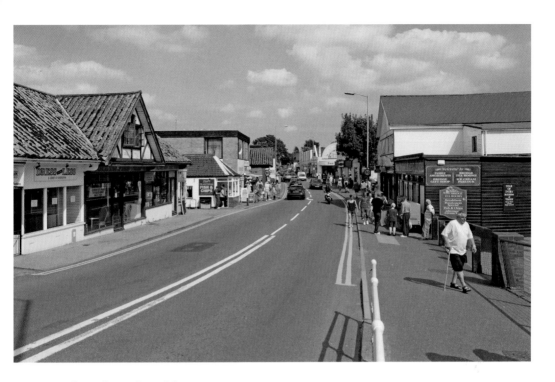

Wroxham from the Bridge

Well . . . not quite . . . as explained, this is actually Hoveton. The modern picture was taken from the footbridge, as the traffic will not allow any photography on the road bridge. The medieval bridge has been a traffic bottleneck for years, but the old bridge is currently protected by a steel deck on which is laid an asphalt carriageway. Bypass plans were unveiled by the county council in 1988, and confirmed by Statutory Instrument in 1992, but then controversially dropped again in 1996.

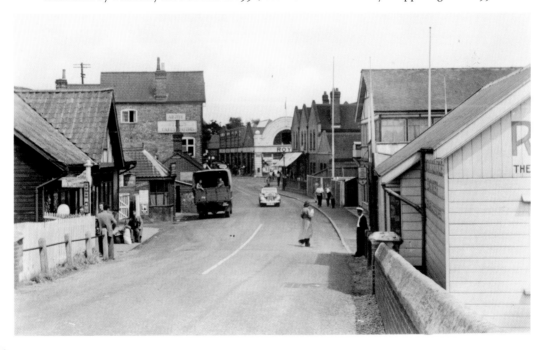

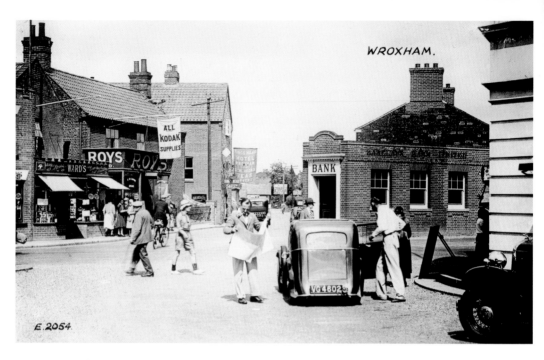

Church Road, Hoveton

Elements of the scene shown in the earlier photograph, dating from around 1948, remain today, although the Barclays Bank was rebuilt after the fire of 1995. However, the one certainty about Wroxham and Hoveton today is that one cannot stand in the street reading the newspaper.

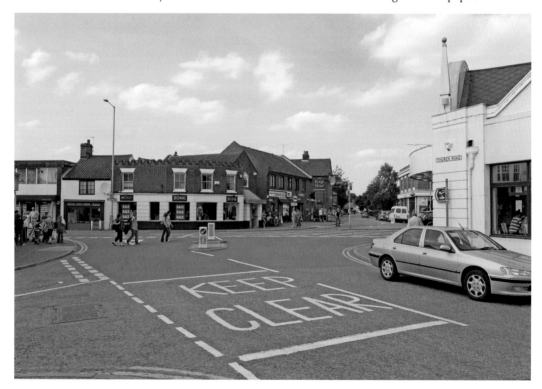

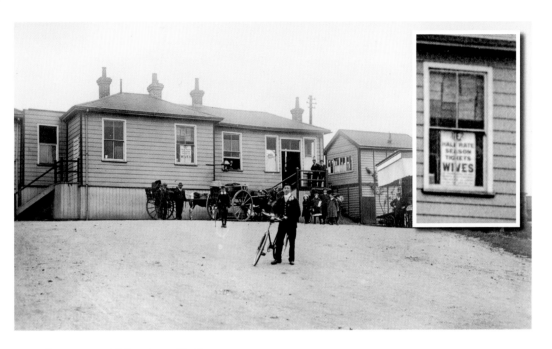

Hoveton and Wroxham Station

Now an unmanned halt on the Bittern line, and still served by trains to Norwich, Cromer and Sheringham, the station stimulated the growth of Wroxham as a tourist centre. Londoners could get here quickly from Liverpool Street, and village lads would carry their trunks (at a price) to the waterside for a yachting holiday. The sign inside the station window in the older photograph has been enlarged (see inset) – a politically incorrect piece of advertising from around 1910.

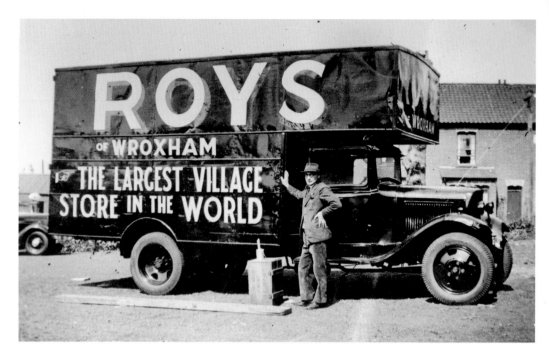

Roys Delivery Vehicles

The old photograph – from around 1946 – shows the Roys removals van in Tunstead Road after the sign-writer has just completed the slogan 'The Largest Village Store in the World'. This boast would be unacceptable today, unless it could be proven, and the definition of 'village' would make such a proof all but impossible. Driving the new DAF 85 410 Day Cab with articulated unit in and out of the Roys delivery yard in Church Road takes skill and confidence.

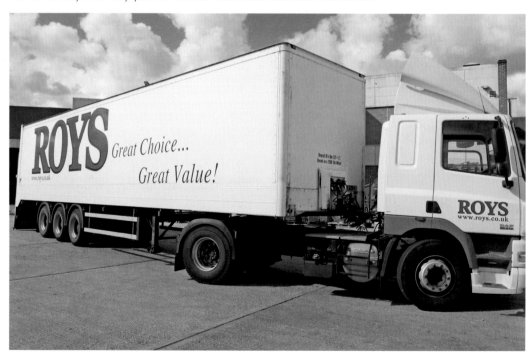

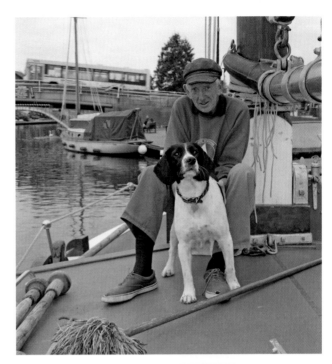

Wherrymen

The older picture is a famous image of the wherryman William Royall on the wherry *Spray* moored close to Read's Flour Mill in the port of Norwich, taken on 31 March 1933. The other photograph was taken at the end of the 'farewell tour' of the pleasure wherry *Hathor*, in Wroxham, 17 September 2009. The weather was cool and grey, the light dim at well after 6 p.m., but skipper Peter Bower kindly posed with dog Sam (officially Samson). The *Hathor* will now not sail again until extensive repairs are completed. Everyone with an interest in the Broads should help the Wherry Yacht Charter Charitable Trust to find the money to complete the restoration work.

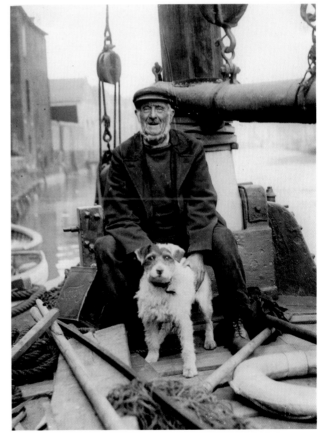

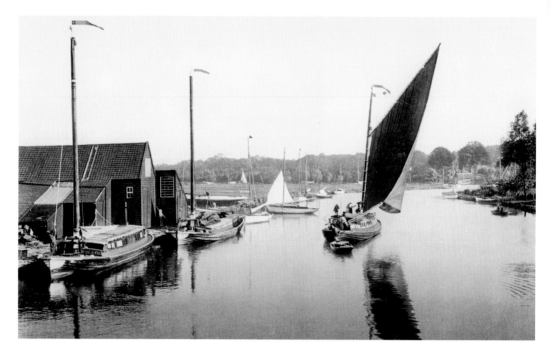

The View from Wroxham Bridge

Always a lively and diverting scene, with boating activity against a background of an attractive wooded valley, but the two pictures – one from 1890 and the other from 2009 – show spectacular change. Two of three wherries in the earlier picture are converted from traders to pleasure craft, and of these the one closest to the camera is the *Britannia* operated by Ling & Co., based at Buxton Mill. The other moored wherry is a trading vessel.

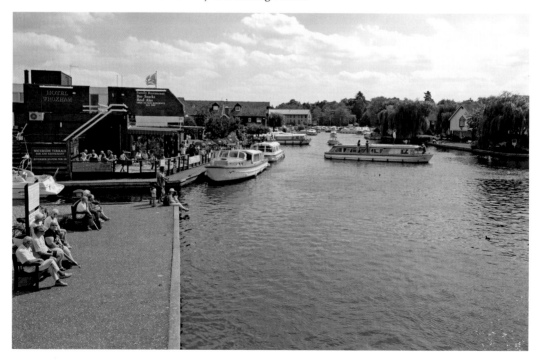

Salhouse Broad

In 1960, it was proven that most of the Broads were former peat diggings, and the evidence came from geologists, botanists and historians working together under Dr Joyce Lambert. Since then, there has been a great deal of erosion and much of the visual evidence has gone. Salhouse Broad has retained its character but the beach-like edges of the broad are further back than they once were, and the banks have been partly quay headed to prevent further erosion.

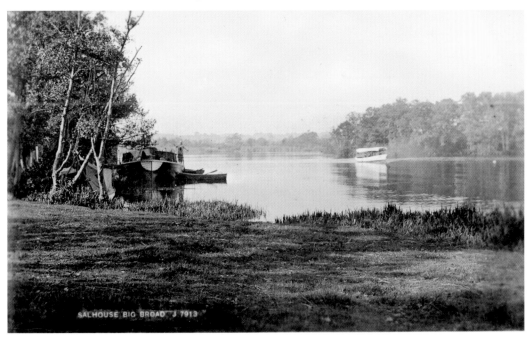

SALHOUSE BIG BROAD J 7913

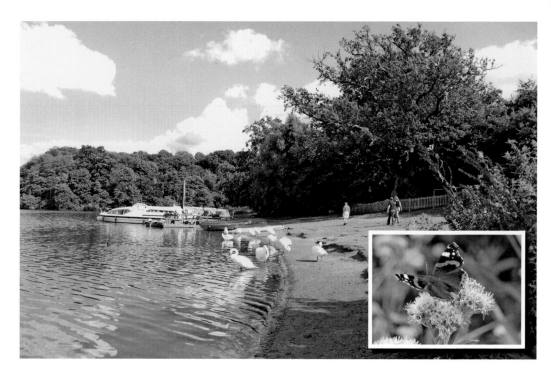

Salhouse Broad

Salhouse Broad today is still a pleasant place to visit, both by land and water, and in the summer, it is possible to hire canoes at the water's edge, or take a ferry to the nearby Hoveton Great Broad Nature Trail. Access from the village is by means of a well-kept pathway and a section of boardwalk. My visit in late August was enlivened by several Red Admiral butterflies feeding on hemp agrimony, including the one shown in the inset.

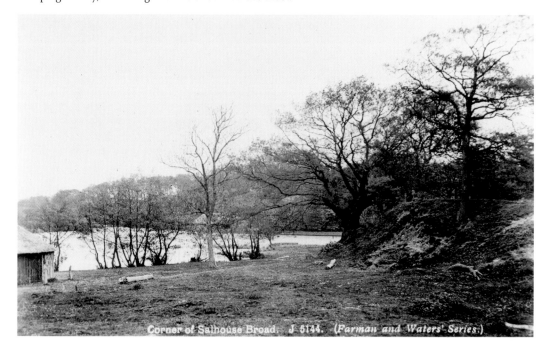

Corner of Salhouse Broad. J 5144. (Farman and Waters' Series.)

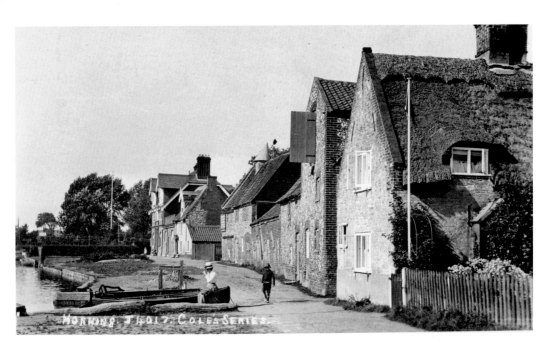

Horning Staithe, 1924 and 2009

A range of quayside buildings have gone, leaving a pleasant open space close to the river, managed by the parish council, and the riverbank has been straightened and re-established further out than was the case in earlier times. Cars are now parked in places where it would be so much nicer not to see them. Both pictures show the Swan Inn, which incorporates part of a seventeenth-century cottage although the main building dates from the nineteenth century.

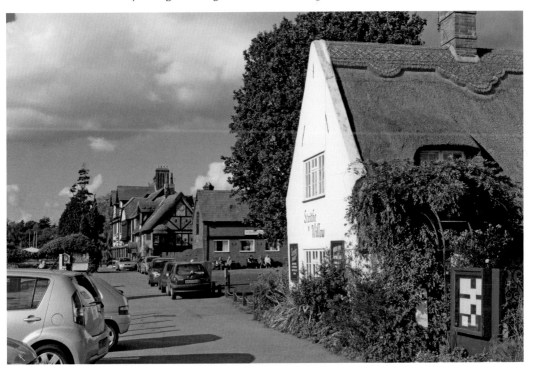

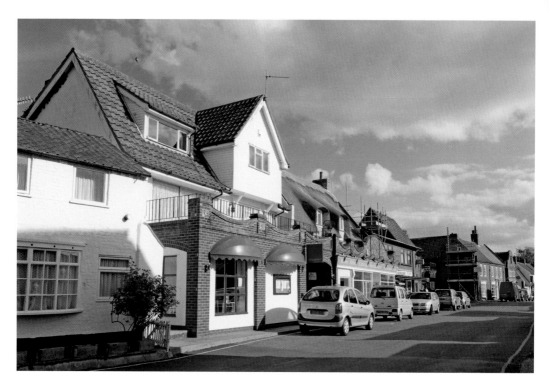

The Street, Horning 1909 and 2009

The houses in the foreground of the older picture have been replaced, and the shop next door has been extended outwards. The next group of buildings have all gone. In the modern photograph, note the new sedge cap of the thatched Bure River Cottage Restaurant, a distinctively East Anglian way of putting a decorative and weatherproof finish to the ridge of a thatched roof.

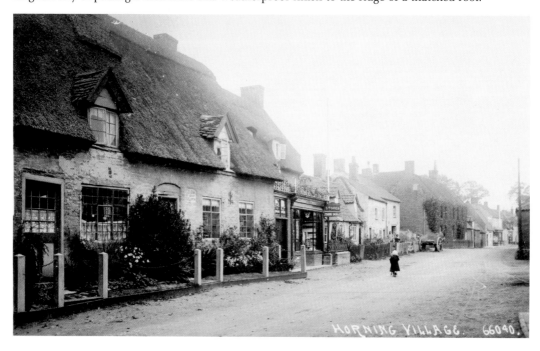

HORNING VILLAGE. 66040.

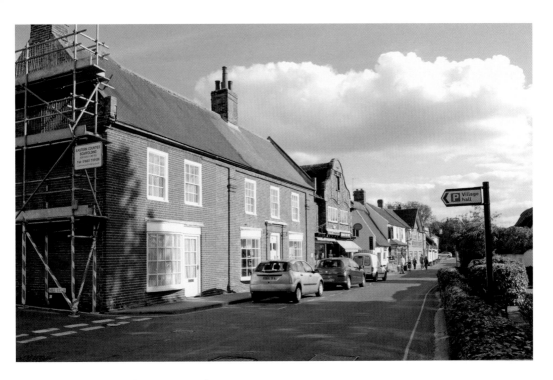

The Street Horning, 1930 and 2009

The building in the foreground has been stripped of its vegetation and its fence, but otherwise much is still recognisable. In order to build modern houses on the site of the former Horning Post Mill, Mill Loke was widened for traffic. The mill rather dramatically dominated the view from the river until it was demolished in 1879.

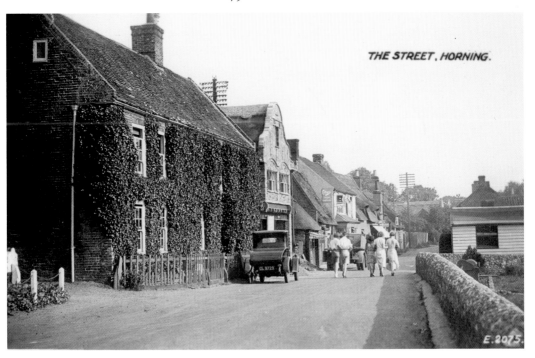

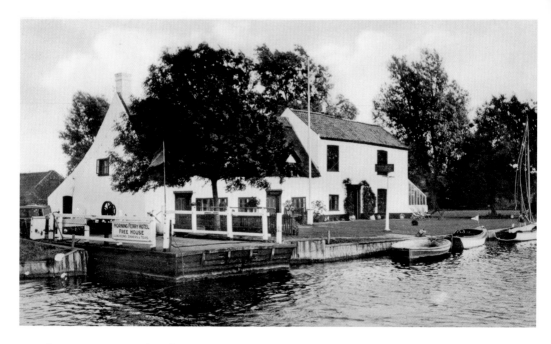

Horning Ferry Inn, 1936 and 2009

Sadly, in the summer of 2009, the Ferry Inn was closed and offered to let. The earlier picture still shows the chain ferry itself, left foreground, big enough for vehicles and carts, although foot passengers used another ferry, moored in front of the inn. This building was bombed on 26 April 1941, with the loss of fifteen lives. Even in 1936, 'Ye Olde Ferry Inn' boasted 800 feet of river frontage, parking for 250 cars and an eighteen-hole putting green.

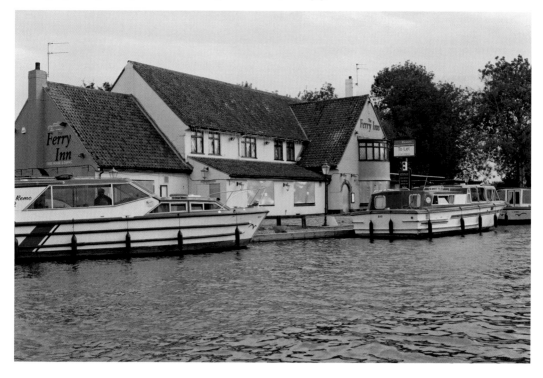

Horning Mill, 1919 and 2009

The drainage windmills of the Broads make an important contribution to the local scene, and those that remain are often protected, at least to a limited extent, by their status as listed buildings. This was an idea that came too late to stop the astonishing 'conversion' of Horning Mill by the builder H. P. E. Neave of Catfield for a private client in 1935. At the same time, the open riverbank was developed with several waterside properties of varying quality.

Ranworth Staithe

The surfaces are harder, the edges straighter, there is a high fence and the trees have grown tall, but nonetheless, these pictures, roughly sixty years apart, show the enduring appeal of Ranworth. The staithe gives direct access to Malthouse Broad, and in summer the *Helen* provides a ferry trip to the Norfolk Wildlife Trust's Conservation Centre overlooking Ranworth Broad. A visit to Ranworth is incomplete without calling at the Church Tea Rooms, in the shadow of one of Broadland's finest churches, St Helen's.

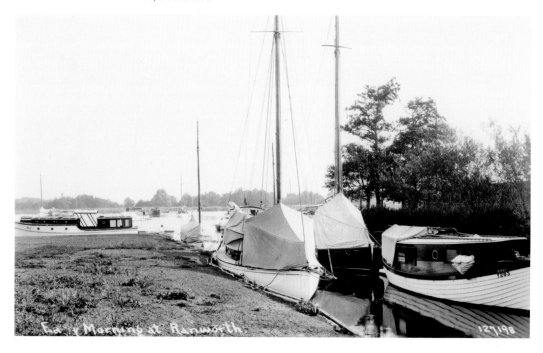

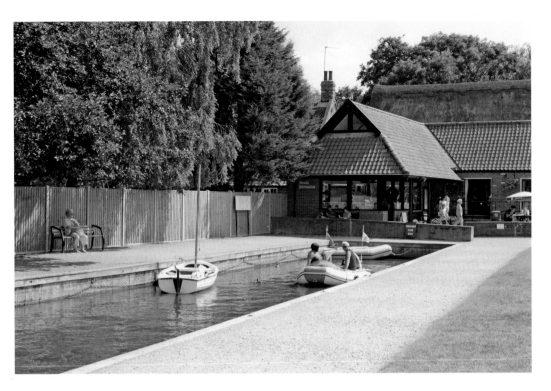

Ranworth Staithe, 1920 and 2009

The cottages in the old photograph are still there, but hidden behind trees. The Broads Authority's information centre has been neatly designed to fit into the corner at the head of the dyke, which is now reserved for rowing boats and dinghies. It is perhaps a shame that everything has to be so rectilinear and neat, but at least this ensures easy access for everyone.

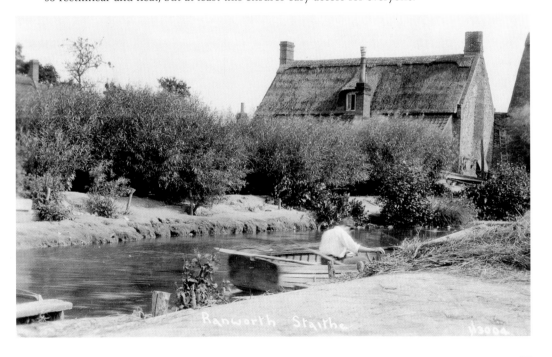

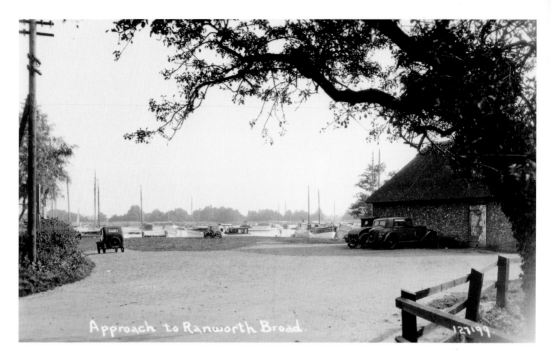

Approach to Ranworth Broad.

127199

Car Park at Ranworth Staithe

In order to provide more space for quiet recreation and picnic parties, the present car park has been reduced in size. The old granary has been converted into a shop and restaurant, and a thatched roof has given way to pantiles. The main difference in the eighty-year gap between the photographs is that, once, nearly all visitors to Ranworth came by water, and now, the majority come by road.

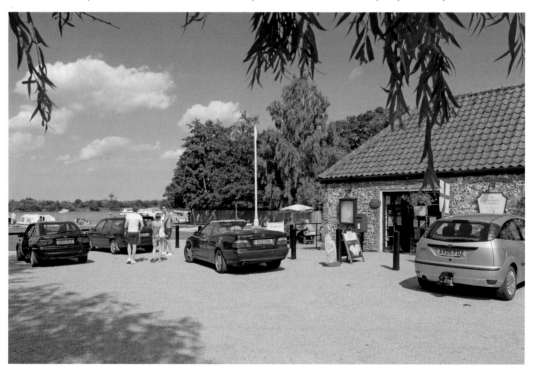

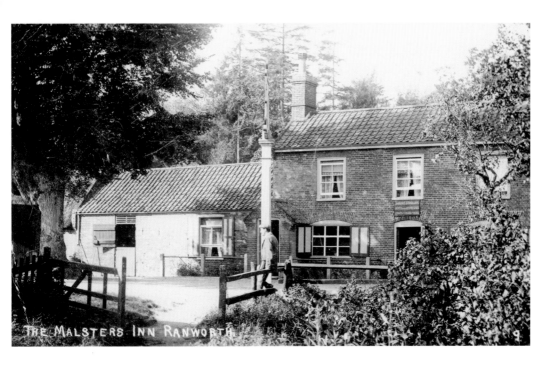

The Malsters, Ranworth

A much-loved public house at the heart of the Broads, the Malsters was fully operational again during the summer of 2009. Regulars were shocked when the licensees closed the pub 'permanently' on 30 November 2009. The licensee in 1920, when the sepia photograph was taken, was Sarah E. Starling; she kept the inn from 1893 until 1923. She was one of three members of the Starling family who ran the pub, for the owners Steward & Patteson, for seventy-six years until 1956.

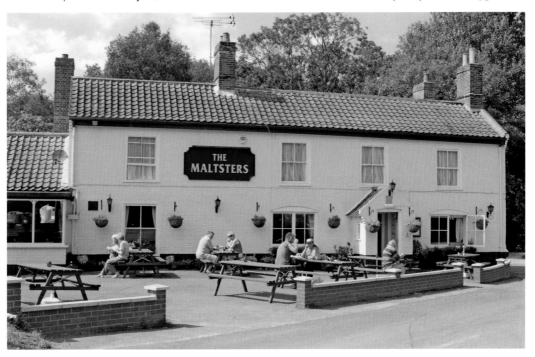

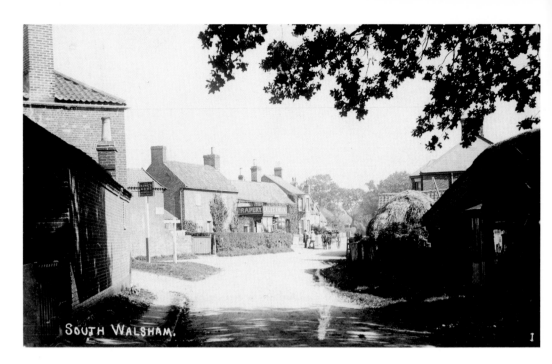

South Walsham, the Street from Burlingham Road

The King's Arms, when the older photograph was taken in 1909, was a Lacon's house – serving ales from the famous Yarmouth brewery which was taken over by Whitbread in 1965, and was closed only three years later. Also visible is Mr E. Alexander's shop – post office, grocery and drapery for the village. The King's Arms still flourishes, perhaps more noted now for its Cantonese cuisine than for its ales.

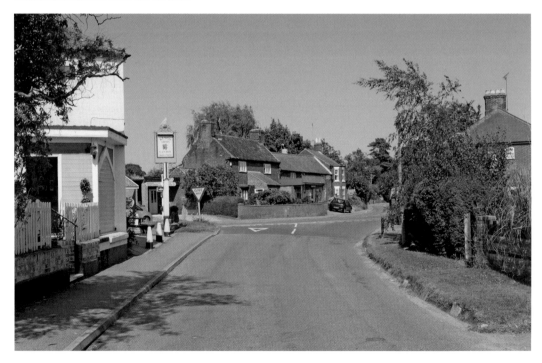

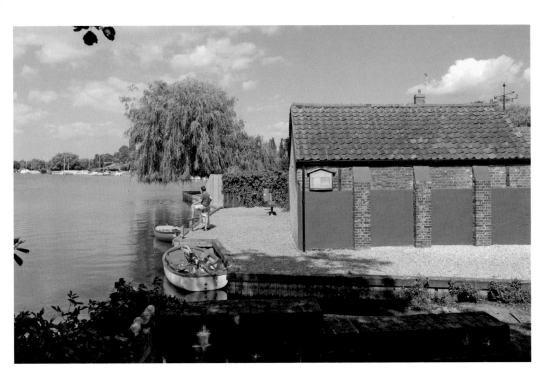

South Walsham Staithe

The present staithe on South Walsham Broad is tiny, and land that appears to be open for public access in the view from 1911 is now very definitely private. This is an issue that has afflicted many of the older Broadland staithes, and it is a frustration, although there is no suggestion that the process has happened in any way improperly. The wall in the immediate foreground of the 2009 view marks the outer corner of the larger building in the older picture.

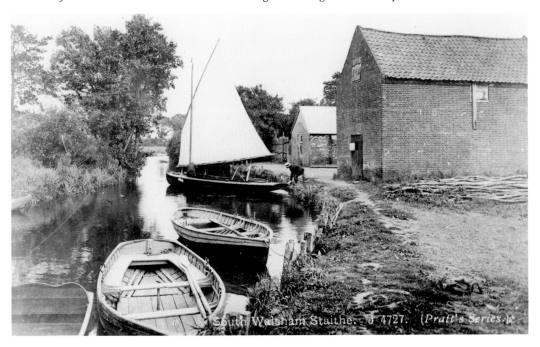

South Walsham Staithe. J 4727. (Pratt's Series.)

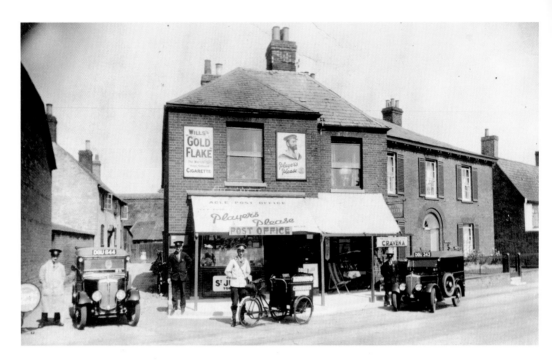

Shopfront, Acle

The curious shape of the post office in the 1920 photograph remains distinctive and, indeed, is even more unusual with the shopfront added at a later date and still wonderfully maintained by the Acle dental surgery. The range of little delivery vehicles and their smart, uniformed drivers standing still for the photographer makes the old picture a real gem, however. Rather charmingly, Salisbury House, to the right of the old post office, still retains its attractive shutters and Georgian doorway.

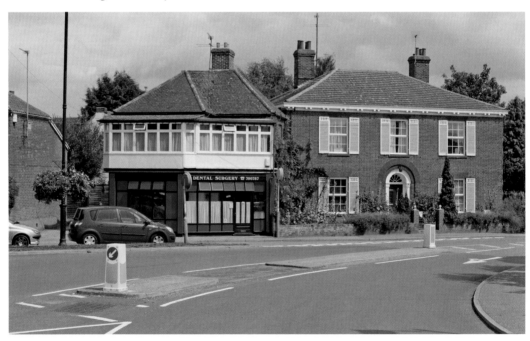

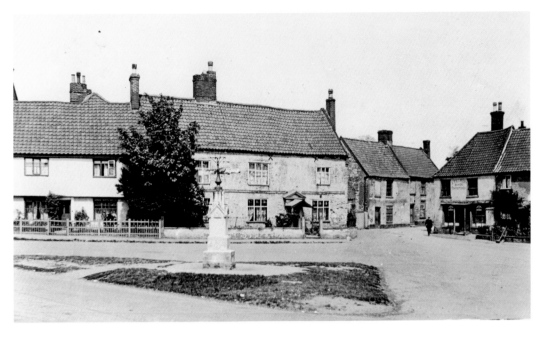

Acle Village Centre and Green

Several of the older buildings remain in the modern picture, and indeed many look rather more cared for now than they did just after the privations of the First World War when the other photograph was taken. The old building at the centre in both photographs is thought to date from the sixteenth century. Note the horizontal line on the front elevation of this house, known as plat banding. The 1897 Jubilee Monument is also visible in both shots.

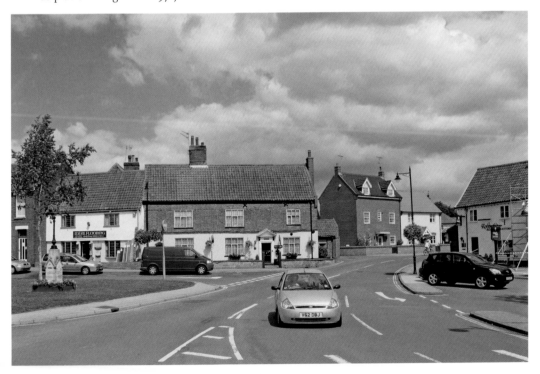

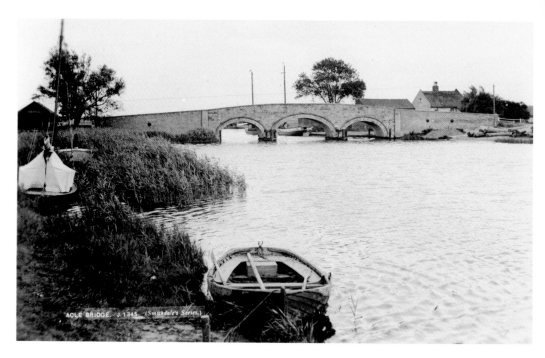

Acle Bridge

The old Acle Bridge, shown in 1908, was highly picturesque but was tricky for yachts, as there was often quite a tidal surge under the arches. It was also a single-track road, so it was understandably replaced in 1931 (see inset). However, this bridge was showing signs of subsidence, and was required to meet European standards for heavy loads, so it too was replaced in 1997.

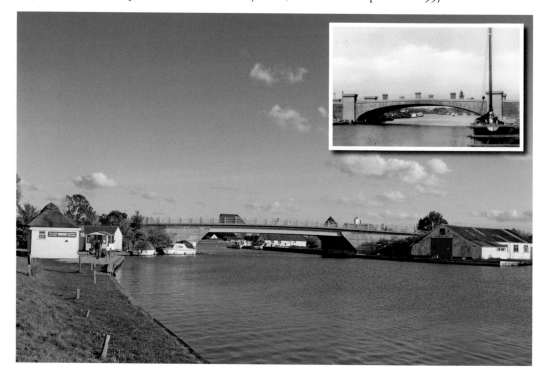

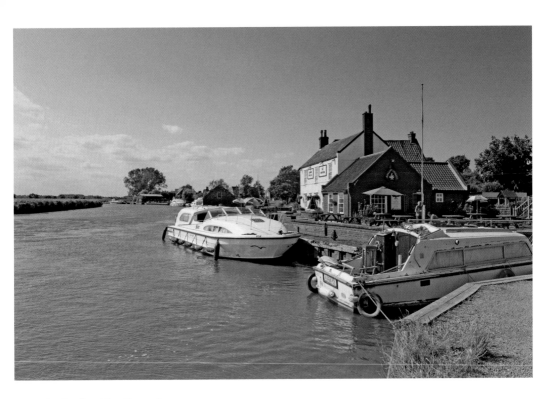

Stokesby, The Ferry Inn

Two views from almost the same spot on the north bank of the River Bure, one from 1935 and the other from 2009. The Ferry Inn, built in 1890, was another Lacon's house, now serving Adnams Southwold ales: it was named after the ferry which took passengers and cattle across to the grazing marshes.

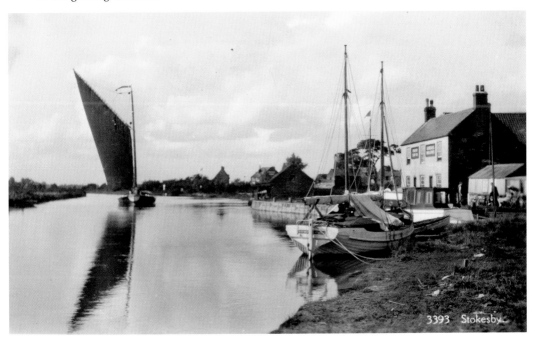

3393 Stokesby

The Sportsman's Arms Staithe, Ormesby St Michael (Little Ormesby)

Once a very popular 'charabanc' ride from Yarmouth, the Sportsman's Arms was a lively inn with its own jetty for hire of small boats on Ormesby Broad. The earlier picture dates from around 1925, but the site is now closed and fenced off, and the pub itself has long since become a private house. The modern photograph shows Ormesby Broad, one of the cleanest and clearest of them all, from what is now a private jetty.

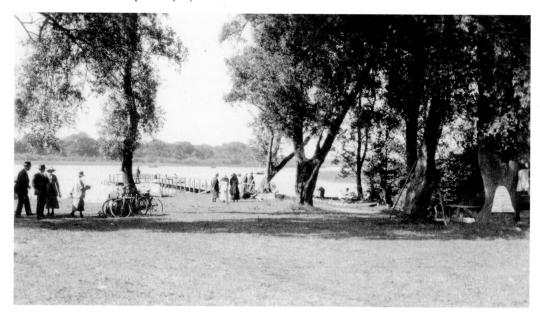

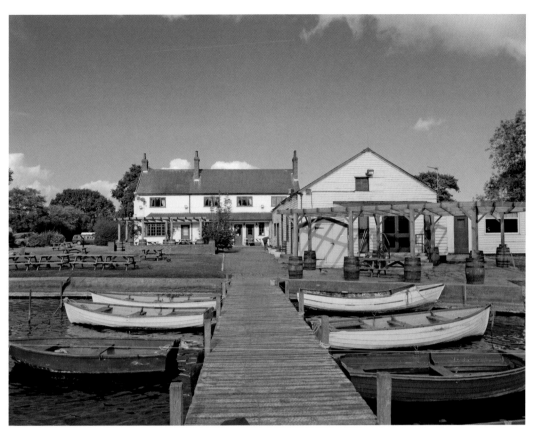

The Eel's Foot, Ormesby, 1922 and 2009

Another popular destination within a short drive of Yarmouth, the Eel's Foot Pleasure Gardens and Inn had its own jetty and dinghies. Clearly enlarged between the two photographs, it still has its own fleet of small boats and is still a popular hostelry. The Eel's Foot looks out on to Ormesby Little Broad.

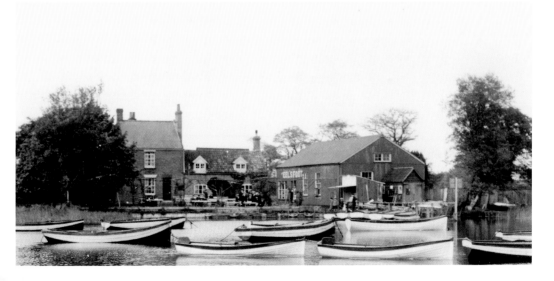

A GLIMPSE OF FILBY BROAD. NORFOLK

Landing Stage, Filby

On the north side of the A1064 Acle to
Caister and Yarmouth road, at the eastern
end of Filby village, is a landing stage from
which it is possible to hire dinghies for
rowing and fishing, although this leads to
Ormesby Little Broad, not Filby Broad. The
earlier picture was taken in 1934 – what
a pleasure to find the old oak tree is still
there after seventy-five years. Together, this
group of broads is known as the Trinity
Broads, although no one knows who first
coined the term. James Wentworth Day
certainly knew them as the Trinity Broads
in 1951 when he wrote his evocative book
Broadland Adventure. There appear at first
glance to be three sheets of water, divided
by two main roads that cross the group at
Rollesby and Filby Bridges. In fact, there are
five separately named broads – Ormesby,
Rollesby, Ormesby Little, Lily and Filby – as
well as smaller pools, such as Fleggburgh
Little Broad, which are also included within
the grouping of the Trinity Broads.

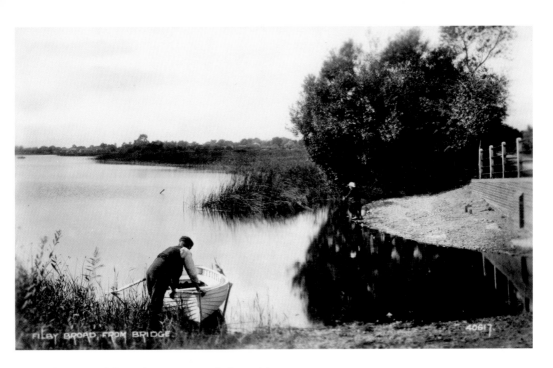

Filby Broad from (Very Near to) the Bridge

Both pictures are taken from the edge of the broad just south of the road bridge, looking south-eastwards. It isn't quite possible to get to the exact vantage-point of the old picture, which was taken in 1922; the banks are uncertain and heavily vegetated. The Essex and Suffolk Water Company filters drinking water from Filby and the other Trinity Broads for Yarmouth, so the water quality of these broads is carefully maintained.

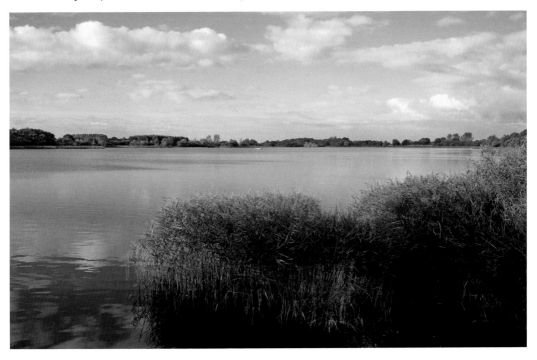

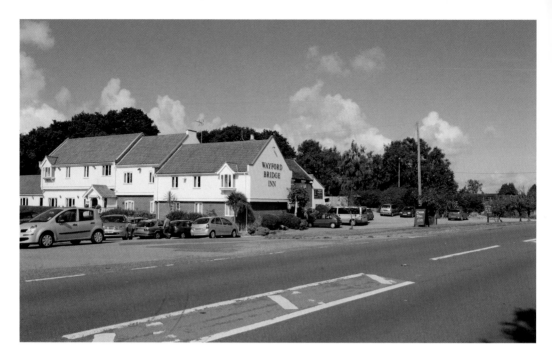

Wayford Bridge Inn 2009, and Wood Farm Free House 1951

At the time of the earlier photograph there was also holiday accommodation at the Wayford Bridge Hotel, on the Norwich side of the Bridge. This hotel closed in 1962, but the Wood Farm free house, tearooms and stores continued to flourish. The modern picture, taken in a momentary gap in the traffic, shows that the present A149 follows a more southerly alignment than the old road. The recent expansion of the inn has been substantial, almost obscuring the original building in this view.

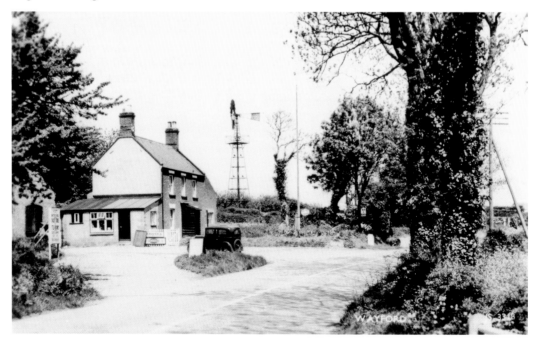

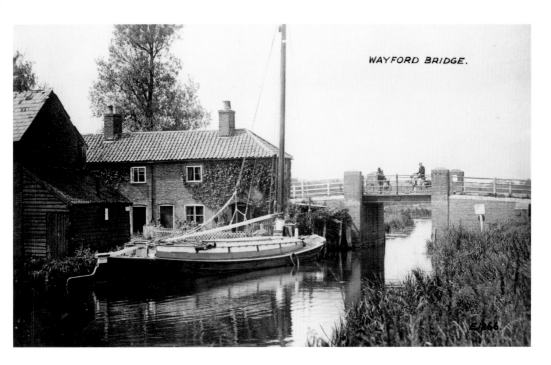

Wayford Bridge from the River Ant, 1920 and 2009

The narrow road bridge has long gone, but the cottages remain. The wherry in the older photograph may have been one of the smaller vessels that could cope with the North Walsham and Dilham Canal, opened in 1826. Some of these wherries were able to slip their keel at this point, to allow progress up to North Walsham via the shallow canal, and stopped at Wayford Bridge to bolt it back in place on the return trip.

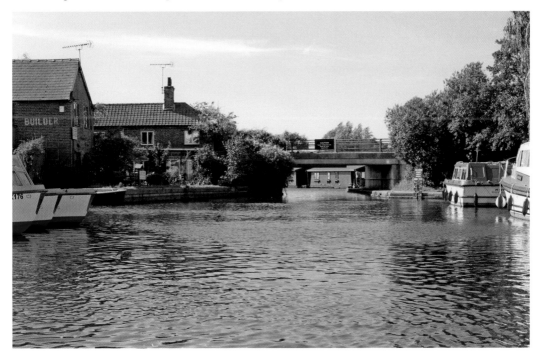

High Street, Stalham, Looking Eastwards

Stalham has changed dramatically, but the temptation to photograph a Tesco supermarket is easily resisted. At the eastern end of High Street the main change between 1906 and 2009 seems to have been dramatic pruning of climbing plants. Looking back up the street, the view suddenly changed in October 2009, as the former hardware shop was demolished. A picture of a gaping hole would have added nothing, so here instead (inset) is a 1912 shot of the lost building.

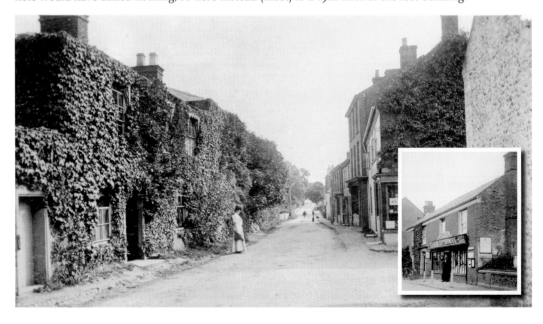

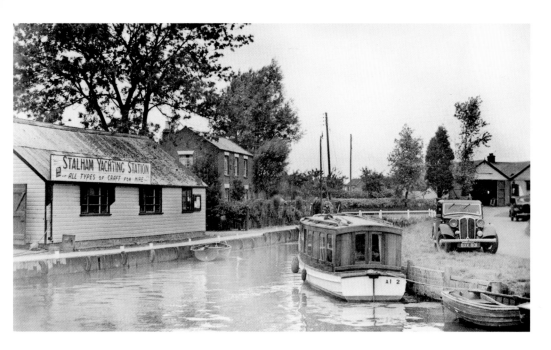

Stalham Staithe

Stalham Yachting Staithe was established by Southgate Brothers, but by the time this picture was taken in 1947 the yard was owned by Messrs Hasselhuhn and Simpson. Their advertisements were a marvel of courtesy: 'owners desirous of disposing of their craft should also consult this agency.' The modern photograph was taken from the Museum of the Broads, always a worthwhile and interesting place to visit.

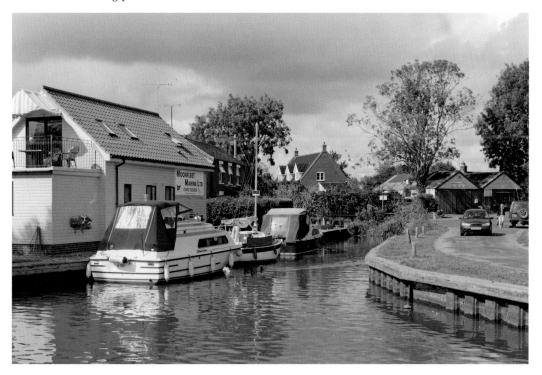

Stalham Staithe, 1930 and 2009

In many respects, these two pictures portray a scene that has changed little. In the centre is one of the special buildings of Stalham, the Old Granary, built in 1808, and beautifully restored in 1977. On the front elevation, this appears as a three-storey building with a loading door at first-floor level. From the water, the rear gable, weather-boarded and now painted white, is distinctive, and the water runs in under the gable to a loading bay for wherries.

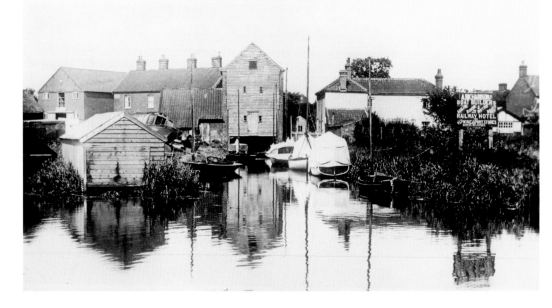

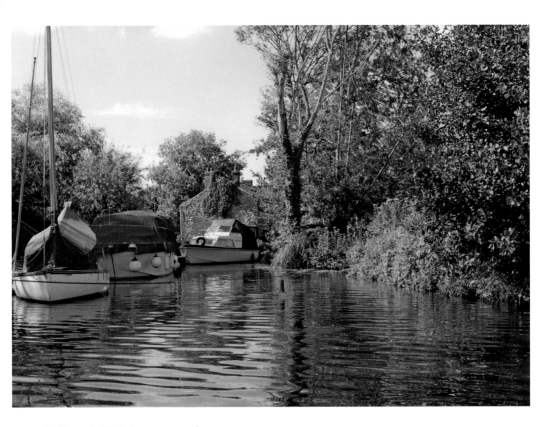

Stalham Mill Dyke, 1909 and 2009

A small corn mill once stood at the head of this little dyke, but only the ground-floor section remains, converted for residential use in the 1970s but now unoccupied, and this is not visible from the river. The cottages, also converted, but rather more tastefully, still remain. The windmill ceased to operate in 1926 and was dismantled in 1930.

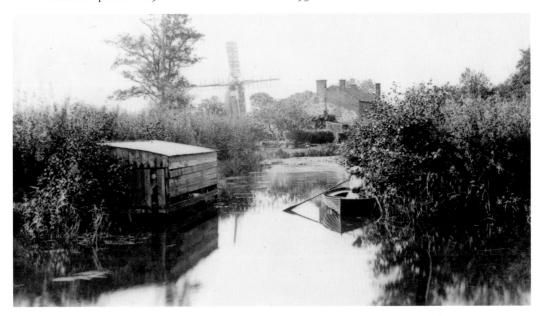

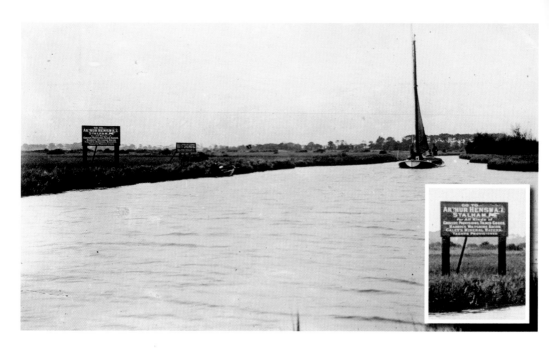

The River Ant – Bear Right for Stalham, Left for Wayford Bridge and Dilham

The earlier photograph, taken in 1909, may look really dull, but to any Broads sailor the absence of trees will conjure up happy days when the Broads could be sailed without loss of wind – or even loss of rigging – caused by overhanging branches. The upper reaches of the River Ant are pretty, but the trees have altered the riverside character forever. On the left, in the 1909 photograph, is a sign – enlarged in the inset – advertising Arthur Hensman's supply stores in Stalham.

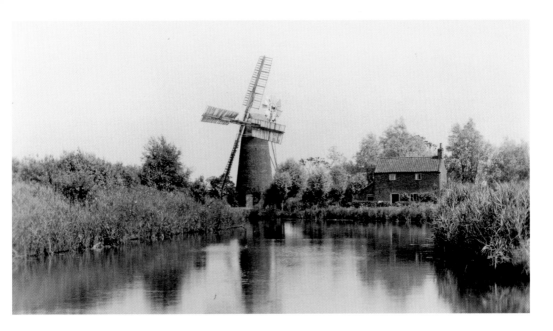

Hunsett Mill, 1934 and 2009

Hunsett Mill has long been one of the most photographed Broadland views, often reproduced on jigsaws and chocolate boxes. Presumably to counteract this image, the architects of the recent reconstruction of the cottage have gone for a minimal design. Planning consent was granted in March 2007. The drainage mill and boathouse are very well maintained: the mill was built around 1860, but it carries a 1698 date plaque, showing that caution is needed when dating buildings from apparently obvious information.

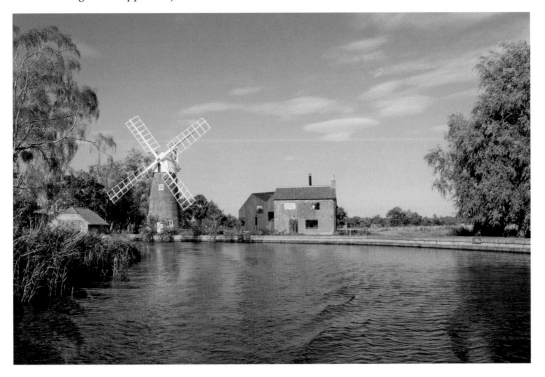

Sutton Staithe

Rather difficult to believe, but these pictures were taken from roughly the same viewpoint. In the early picture (1912), on the left, are the level-crossing gates onto the Midland & Great Northern Railway line. The orientation of the 2009 picture is the same, but trees now obscure this point as well as hiding the modern A149 road following the line of the old railway. The small pair of cottages and boatyard buildings seen in the 1912 view are long gone.

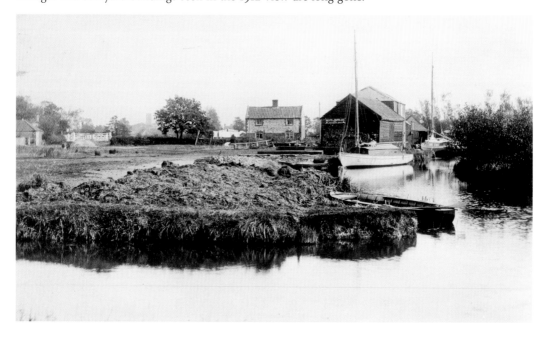

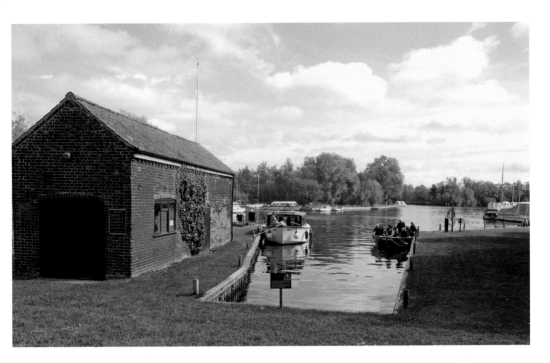

Barton Staithe: the Black Shed, 1932 and 2009

The older picture shows a trading wherry moored in front of a pleasure wherry. The *Black Shed* was the subject of enquiry, under the Commons Registration Act, into disputed ownership (1989). Eventually, it was determined that the shed was parish property, with the staithe on which it stands. The building, also known locally as the Coal House, might have become an information centre as part of the Broads Authority's restoration of Barton Broad, but local pressure forced a change of heart.

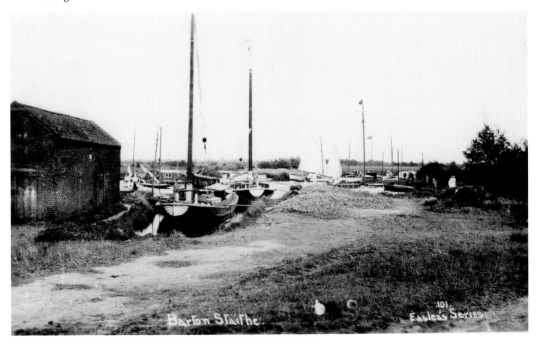

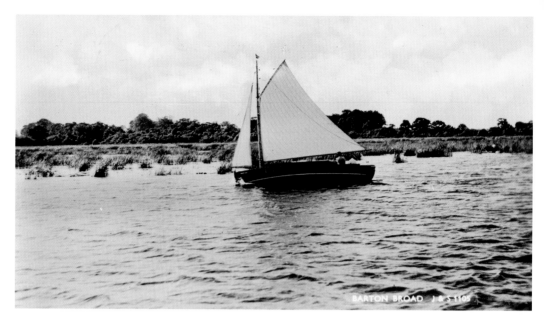

Sailing on Barton Broad, 1949 and 2009

Barton Broad is the second-largest lake in the system. The earlier picture is included because it shows that clumps of lesser reedmace and reeds were encroaching on the open water in the 1940s and 1950s. Then came the dramatic decline in water quality, when large blooms of algae dominated, and larger water plants disappeared. Finally, as a successful millennium project, the broad was suction dredged between 1996 and 2001, giving more room for sailors and improving water quality spectacularly.

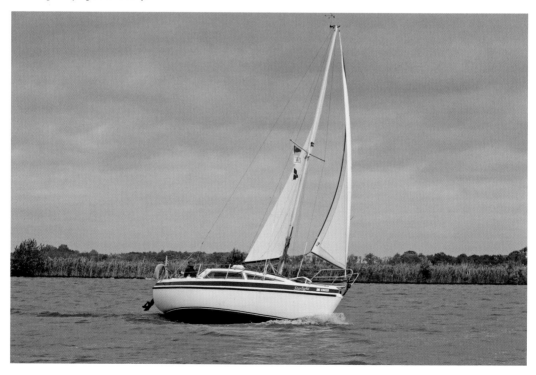

Neatishead Staithe

The older photograph dates from 1931, but the staithe has since been enlarged. As the modern picture shows, a mere dozen boats or so will fill the staithe, which is approached by a narrow dyke from Barton Broad, known as Lime Kiln Dyke. Heavily overgrown with trees, Lime Kiln Dyke is noted for kingfishers and, in recent years, otters.

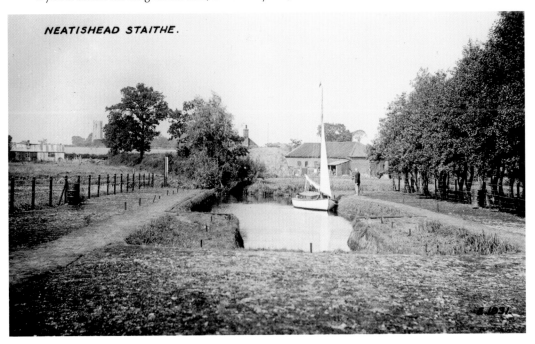

NEATISHEAD STAITHE.

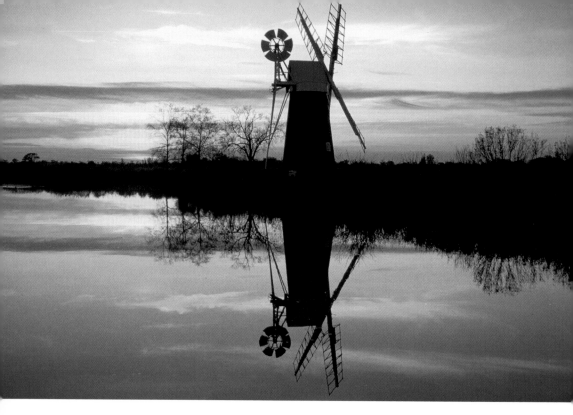

Sunset at Turf Fen Drainage Windmill

Built around 1875 by Yarmouth millwright William Rust, Turf Fen Mill was damaged in the 1912 floods and never really worked well afterwards. The sails are already breaking up in the 1932 photograph. During the 1980s, the mill was extensively restored by John Lawn of Caston, under instructions from the Norfolk Windmills Trust (now known as the Norfolk Mills and Pumps Trust), but now, the cap and sails are showing decay and more work is urgently indicated.

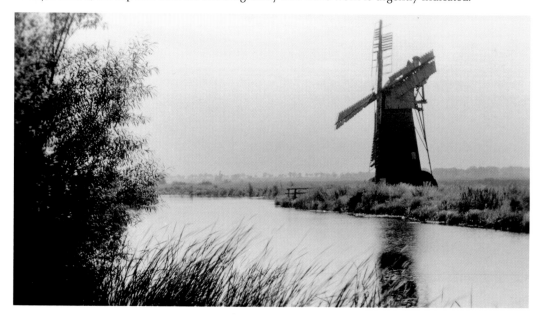

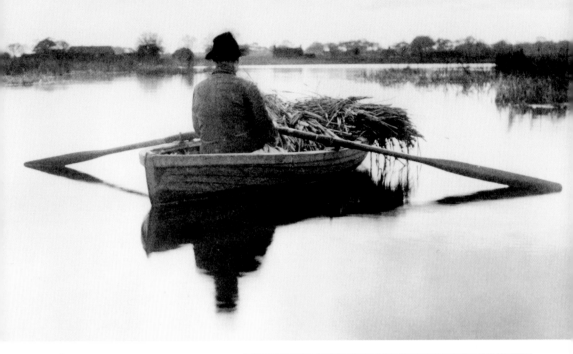

Marsh Harvests

The old photograph is an iconic image of the Broads by P. H. Emerson, entitled 'Rowing home the schoof-stuff', published in 1886. Schoof – pronounced shuff – refers to sedge and other marsh grasses used for loosely covering floors and in thatching. The more recent picture shows the famous How Hill marshman Eric Edwards, MBE, quanting home a lighter fully laden with sedge for thatching, with Boardman's Mill, restored by millwright Richard Seago, in the background.

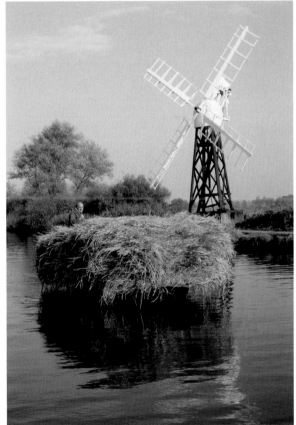

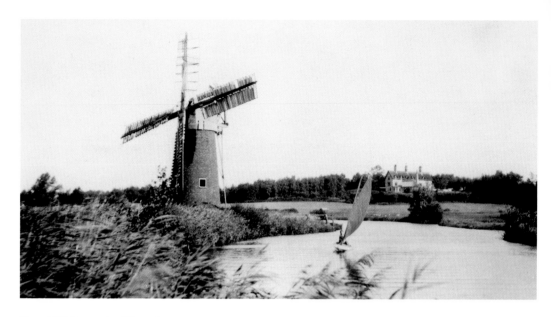

How Hill from the River Ant

The old picture here is from the Boardman family albums, and shows Michael Boardman sailing his dinghy, *Shrimp*, with his family home, How Hill, in the background and Turf Fen Mill on the left, in September 1929. The other photograph, taken on 29 July 2008, shows Peter Bower at the helm of the pleasure wherry *Hathor* on exactly the same reach of the river. On board are members of a How Hill holiday course, enjoying a relaxing cruise in the sunshine.

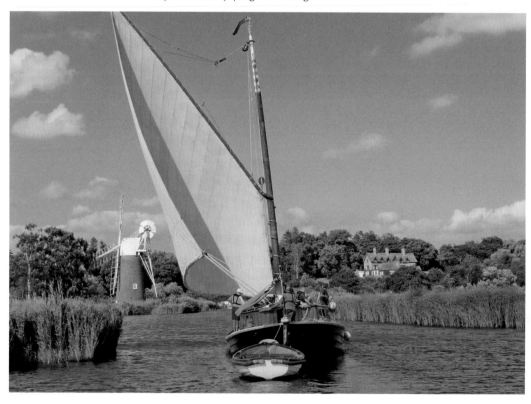

Marshmen

The top picture shows marshman, gamekeeper and countryman Bob Smithson cutting reed at How Hill in the winter of 1969. Bob, who died recently at the age of ninety-one, was a great fund of wisdom and knowledge about man and nature in the Broads, and he is irreplaceable. Bob Smithson worked for the Boardman family at How Hill as a gamekeeper – and more besides – and when Norfolk County Council purchased the How Hill estate in 1967, the council continued to employ him. In his new role, he was required to take groups of children on expeditions to discover the natural history of the marshes, as well as looking after the marshes. He was known – quite inexplicably – as 'Higgatt' by the other estate workers, and he continued to help on local shoots even whilst employed at How Hill. When the county council sold How Hill at the end of 1983, Bob retired, but he carried on his other gamekeeping work, and he contributed regularly to shooting magazines, and even published a book on 'rabbiting' in 1988. Eric Edwards, MBE, seen in the sedge beds at Little Reedham, near How Hill, in October 2009, is also supposed to have retired, but is never happier than when he is at work with a scythe in the marshes: in this case mowing sedge for the ridges of thatched roofs. Eric learnt his craft from Bob, and together, they represent 'the end of the line': marshmen are no longer employed at How Hill.

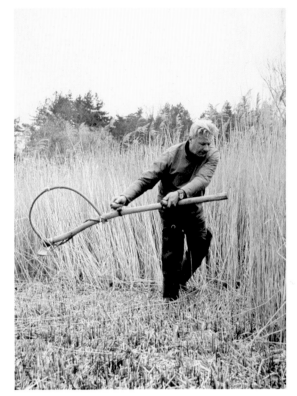

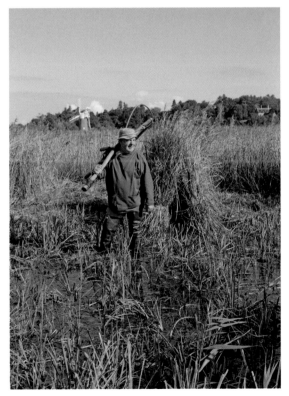

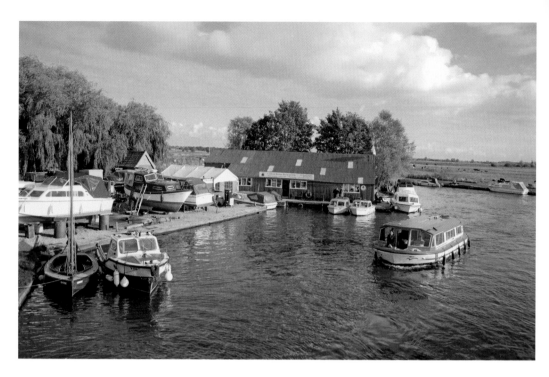

The View from Ludham Bridge

Ludham Bridge Services now occupy this site immediately south of Ludham Bridge on the east bank of the River Ant. The two mills in the 1913 picture have both vanished: the brick-built mill, known as Beaumont's Mill after the marshman who looked after it, was demolished in the 1960s. The bridge itself was originally a narrow, hump-backed brick bridge but was replaced in 1915, not in 1912 as is so often stated, and then rebuilt again in modern times.

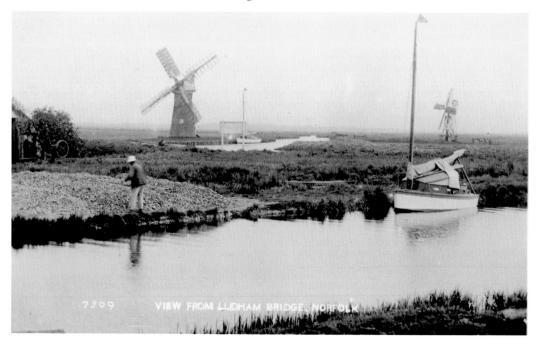

VIEW FROM LUDHAM BRIDGE, NORFOLK

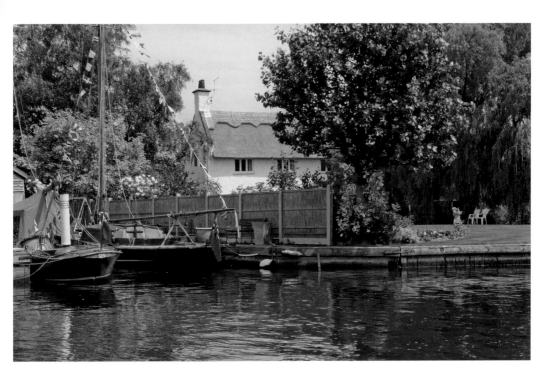

Womack House

Womack Staithe is at the end of a dyke from the River Thurne, and has some glorious gardens on both sides, enabling Ludham village to mount one of the best village garden events, with small craft ferrying delighted visitors from one bankside property to another. The modern picture was taken during this event in June 2009 – note the steamboat as well as the classic yacht moored here. The other picture shows Womack House in 1936 before modernisation.

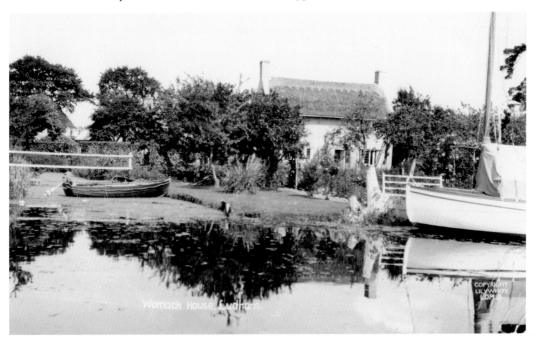

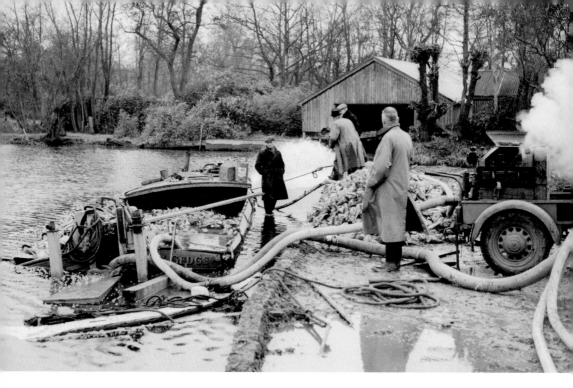

Womack Staithe, Ludham

The older photograph records a sorry episode: the wherry *Gleaner*, dismasted and now only used as a barge, had sunk at her moorings whilst loading sugar beet, in winter 1955. Efforts are proceeding to pump her out and refloat. The 2009 picture represents almost exactly the same spot, and the ghost of the old boathouse can still be identified in the modern boatshed at the centre of the photograph.

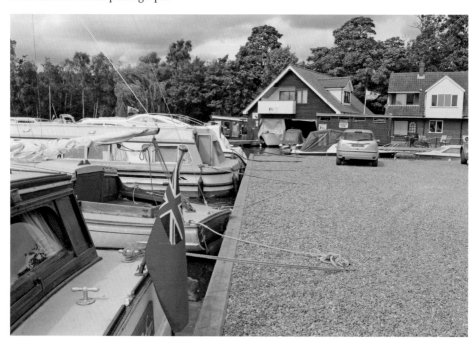

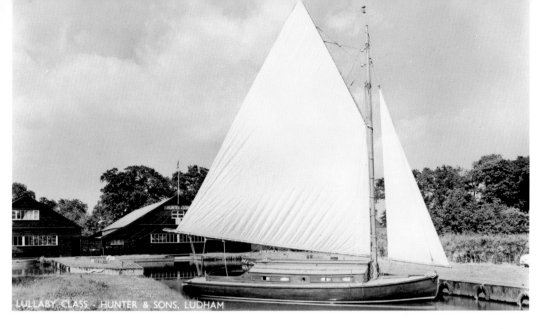

LULLABY CLASS - HUNTER & SONS, LUDHAM

Hunter's Yard, Womack:
Home of Percy Hunter's Classic Sailing Yachts, Now the Heritage Fleet
Hunter's Yard was renowned for quality-built cabin yachts. The yard and boats were taken over by Norfolk Education Committee in 1968 as a sail training fleet. The county council disposed of the property and the boats in 1995, and after securing substantial support from the Heritage Lottery Fund, the Heritage Fleet was saved, and the beautifully maintained wooden craft are still sailing. The old photograph shows one of the three Lullaby class four-berth yachts, newly commissioned in 1932.

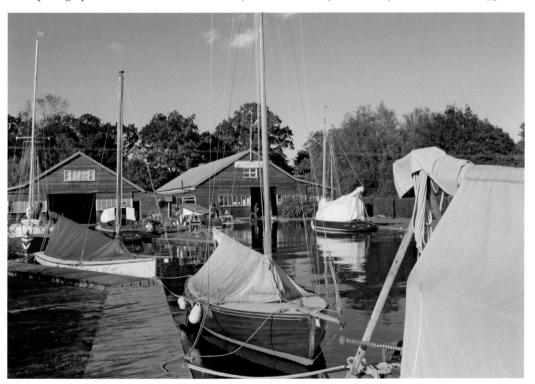

Norwich Road, Ludham

Ludham Parish Council and Ludham residents have fought over the years to protect their heritage, and the result is that Ludham is still a vibrant and flourishing village. These two pictures of the thatched cottages in Norwich Road show various changes, but the modern scene remains a pleasure to behold. What is now Alfresco Tea Rooms was once Albert Wesley Knight's saddlery, also selling horse collars, garden tools, hardware and tack: the older photograph shows this scene in 1937.

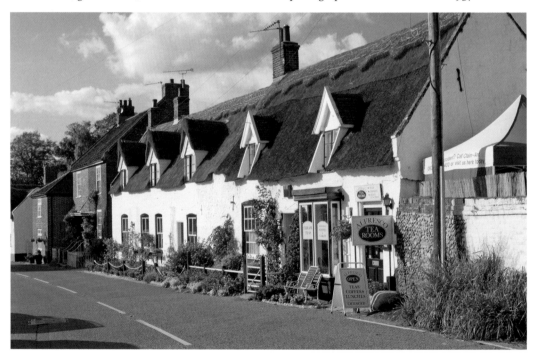

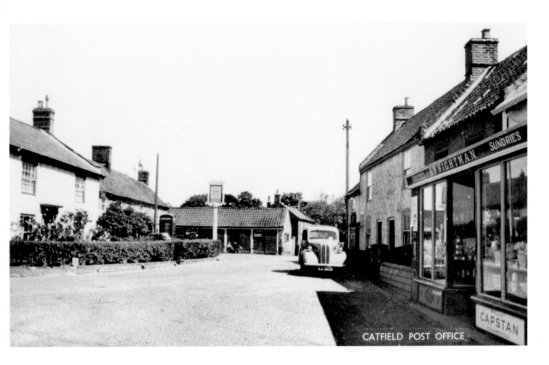

Catfield Post Office

Catfield, once known as 'clever Catfield', as it has parish staithes on both Barton Broad (River Ant) and Hickling Broad (River Thurne), still retains some character despite industrial development on the Sutton Road. These two photographs are from the same point outside Catfield post office, still occupying the same shop in 2009 as in 1954. By chance, the photographs both show Ford cars – a Ford Anglia and a Ford Mondeo. The Crown Inn was another Lacon's house in 1954.

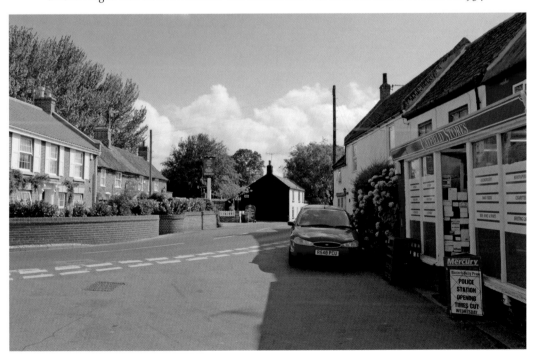

Hickling Village

The lower picture shows Turner's post office and general stores in 1923. There were other shopkeepers in the village, and even as recently as the 1980s, there were three stores in the village (with an extra summertime shop adjoining the Pleasure Boat Inn). Now there are none, and Hickling residents must go to Stalham for supplies. The top photograph shows that the post office is now a private residence, although fortuitously the postman was on his rounds at the time.

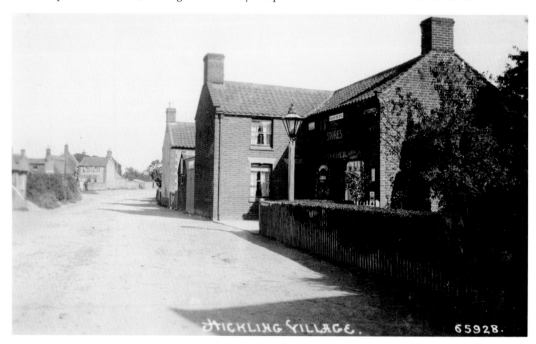

HICKLING VILLAGE. 65928.

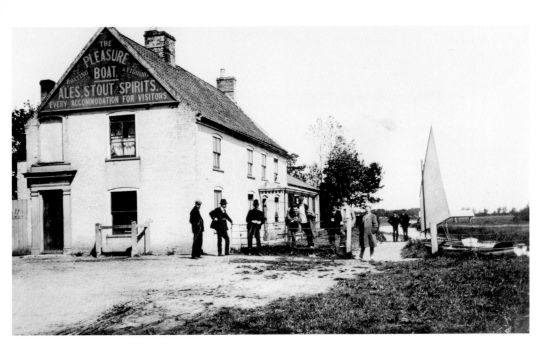

The Pleasure Boat Inn, Hickling

Another famous Broadland public house closed for much of the summer in 2009, although only temporarily. The earlier photograph shows the inn in 1915, some years after it had been extended to provide more accommodation. Hickling Broad was, at this time, one of the finest areas in England for shooting, angling and sailing: a wide open expanse of 460 acres of water with wild marshes stretching on all sides. It is now a National Nature Reserve.

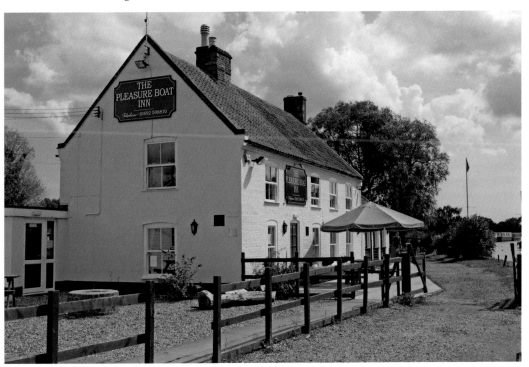

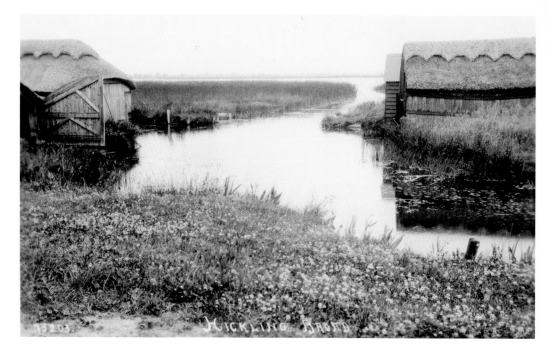

Boathouses at the northern end of Hickling Broad

The small collection of private, thatched, timber boathouses alongside Hill Common at Hickling make as picturesque a group now as they did eighty years ago when the older picture was taken. The true Broads use of the word 'hill' to indicate anything which isn't actually marsh always entertains, by the way; the Ordnance Survey map shows that Hill Common is around one metre above sea level at its highest.

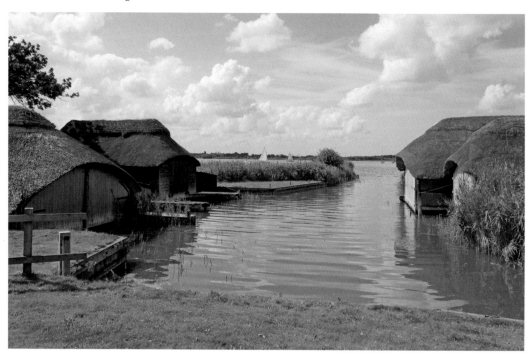

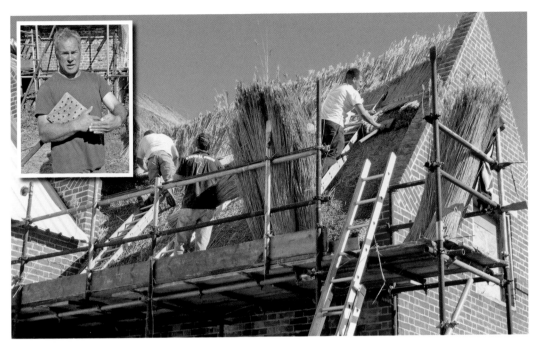

Thatchers at Work; How Hill, June 1926, and Martham, September 2008

Thatched buildings make a major contribution to the Broads scene, and local reed is still used to supply the industry, although increasingly, reed is imported from Eastern Europe. The lower photograph shows the old technique of 'flecking', whereby a woven mat of reed is laid down on the rafters before the main reed thatch is applied. The smaller picture shows master thatcher Stephen Aldred with one of the tools of the trade, a leggatt.

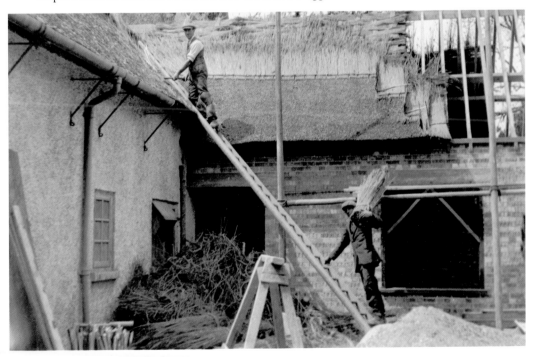

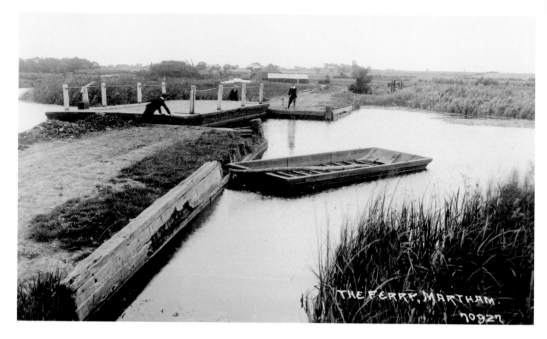

The Ferry, Martham.

Martham Ferry on the River Thurne, 1924 and 2009

The present-day ferry, shown at a right angle to the old photograph, is probably unique. It has a timber deck on steel floats, hinged at the nearest point, and is swung into position. The old ferry was a floating pontoon that plugged the gap between two sections of roadway built out into the river. Crossing the ferry from Martham leads to Heigham Holmes, opened by the National Trust on one day each summer, home to the true marshmallow (see inset).

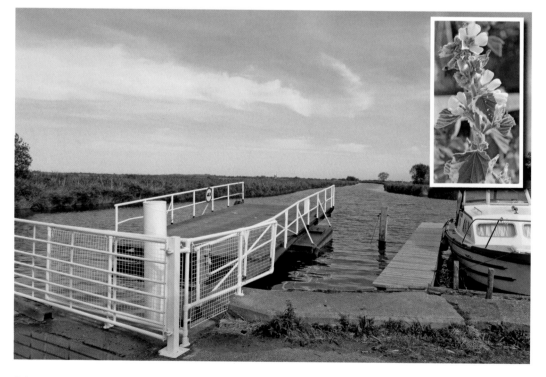

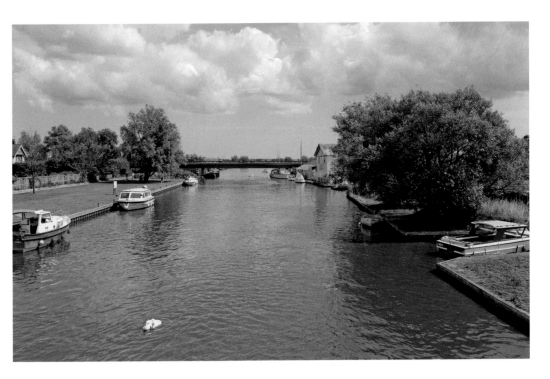

Potter Heigham from the Old Road Bridge

The older photograph shows the railway bridge, first constructed by the Great Yarmouth and Stalham Light Railway in 1879, across the River Thurne. Later, this line merged with others into the Midland & Great Northern Joint Railway. The old bridge was constructed of iron, preserved by repeated coatings of tar and lime. The line of this bridge is followed now by the main A149 highway. The railway closed in 1959, and the earlier picture dates from around ten years earlier.

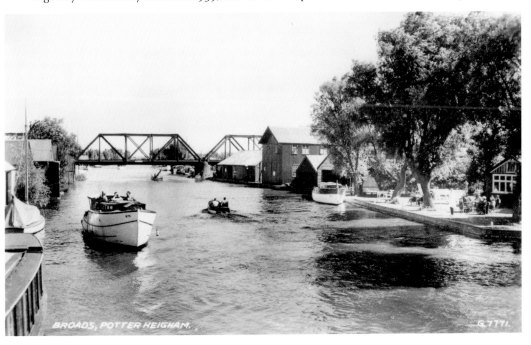

The Old Road Bridge, Potter Heigham

The earlier picture dates from 1924, but a huge void is revealed by the 2009 view. The Bridge Hotel, a noted inn and prominent landmark, was destroyed by fire at lunchtime on Thursday 17 October 1991. Since then, there has been another serious fire in the café and shops on the opposite bank of the river, in September 2007, and those buildings await redevelopment.

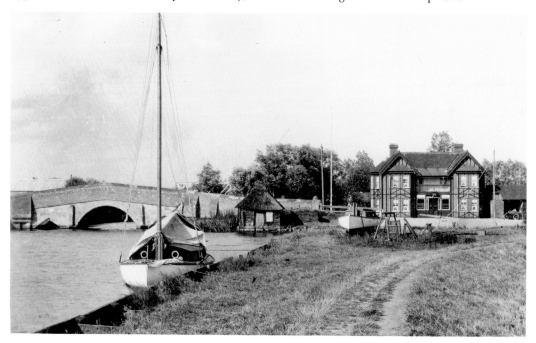

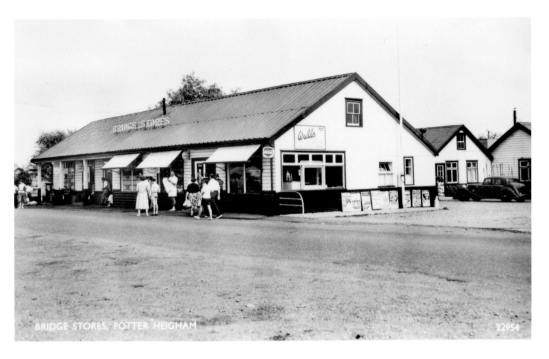

Bridge Stores, Potter Heigham

Two very similar views, one from around 1954 and the other from 2009: a thriving enterprise supplying the needs of holidaymakers and visitors. In Potter Heigham, there are several large, wooden buildings, which have been adapted for a variety of commercial purposes, but in fact, some of them were originally built as dance halls. Holidays on hire boats could be enlivened by a night's dancing to a live band, a real treat in the austerity years of the mid-twentieth century.

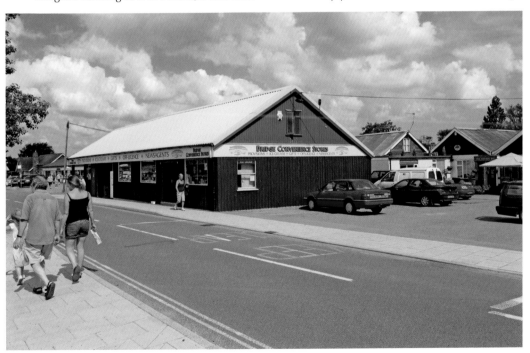

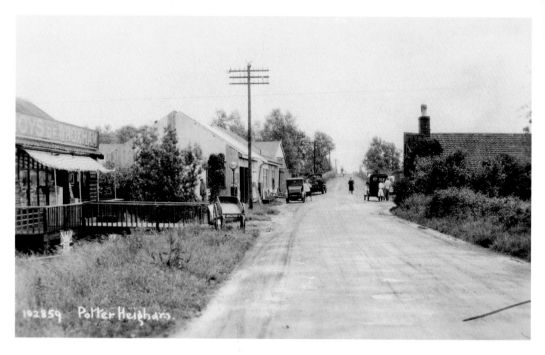

The Approach to Potter Heigham Bridge from the Village

The earlier photograph, from 1932, shows Roys of Wroxham based in a wooden shop, and just behind their shop is Sidney Grapes' garage. Sidney was an engineer, but achieved fame with his comic monologues and eccentric characters, most famously Aunt Agatha. He contributed a series of occasional letters to the *Eastern Daily Press* signed 'The Boy John', always in dialect (originally published between 1946 and 1958). The modern photograph reveals this part of Potter Heigham as drab and commercial.

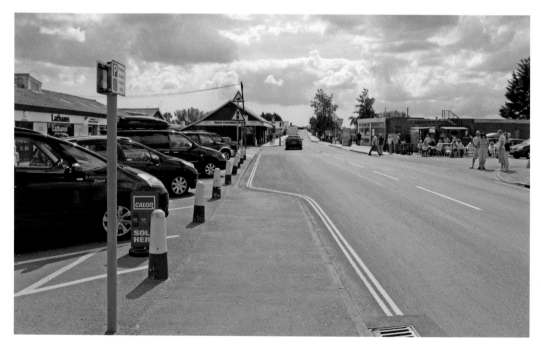

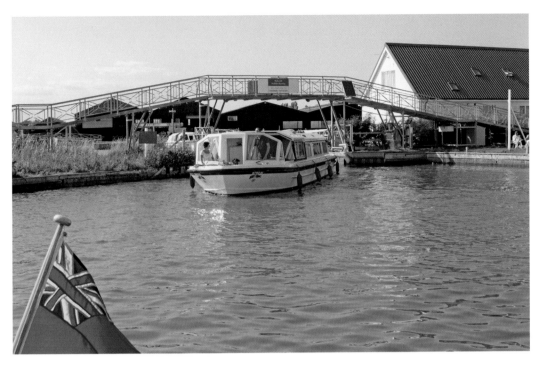

Entering and Leaving 'Broadshaven' from the River at Potter Heigham

The footbridge marks the entrance to the boatyard planned by the Broads entrepreneur Herbert Woods. He began to develop the site in 1929 and the first task was digging out a basin for boats. The older picture dates from 1935 and shows B53 *Shimmer of Light*, a Herbert Woods cruiser, which could then have been hired for as little as £11 per week. The bridge has been rebuilt, and in 2009, it is still possible to walk along the riverbank.

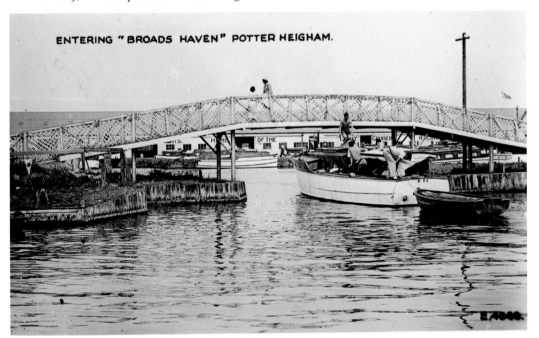

ENTERING "BROADS HAVEN" POTTER HEIGHAM.

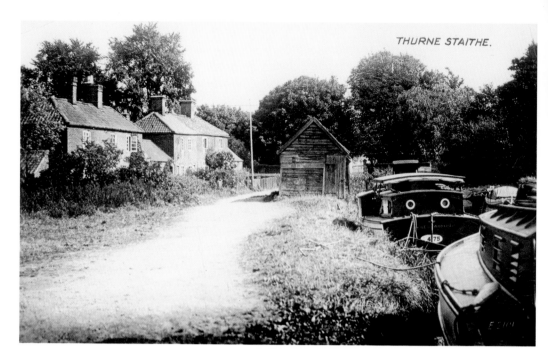

THURNE STAITHE.

Thurne Staithe

The staithe seems more rural and there are fewer straight edges in the earlier photograph from 1937, but it is still recognisable and Thurne village remains a pleasant port of call just off the River Thurne. Visible in the 2009 photograph, at the head of Thurne Dyke, is the Lion Inn, another former Lacon's pub.

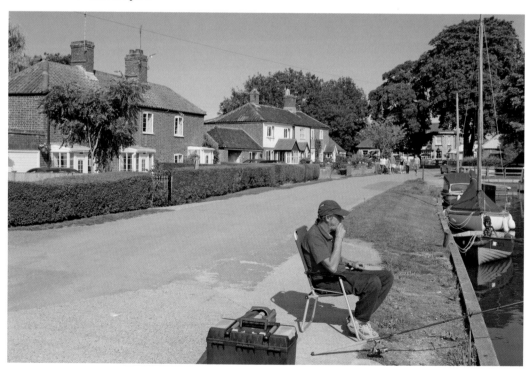

HEIGHAM SOUND, NEAR HICKLING BROAD.

Heigham Sound

Heigham Sound represents a broadening of the channel between Hickling Broad and Candle Dyke. It is one of the celebrated pike fishing waters of the Broads, and one of the best areas to see swallowtail butterflies, marsh harriers and bitterns. The colour photograph was taken after a squall in the afternoon of 27 September 2007, and the other picture dates from the early 1930s.

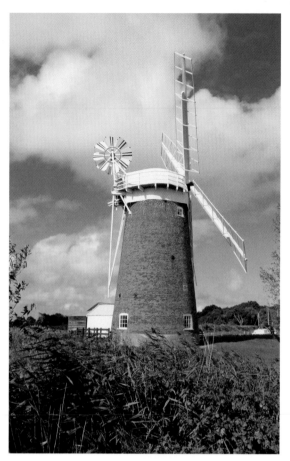

Horsey Drainage Windmill

Often erroneously called 'wind pumps', the drainage windmills of the Broads have served to drain the marshes for grazing since the eighteenth century. The older photograph shows Horsey Mill swamped by the flood of 12 February 1938, when the sea broke through the fragile band of dunes at Horsey and flooded around 7,500 acres of land, as far inland as Hickling. Note that, even at this date, the mill was assisted by a mechanical pump, seen at the left of the tower – neither would have been much use until May 1938 when the sea breach was finally repaired. There had been a mill on this site for perhaps 200 years or more, but the present structure dates from 1912. It was struck by lightning in 1943 and ceased to operate; in 1961 it was fully restored. It lost its fantail in the October 1987 storm but this was restored again. Water is still pumped into the dyke at Horsey, but nowadays, the machinery is powered by electricity.

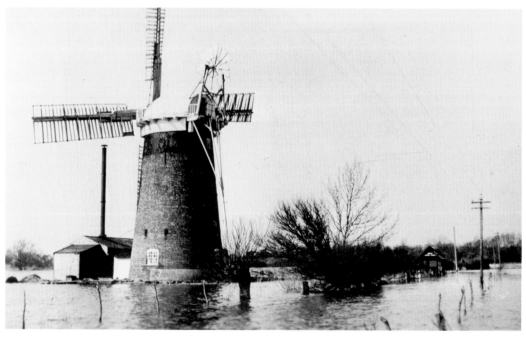

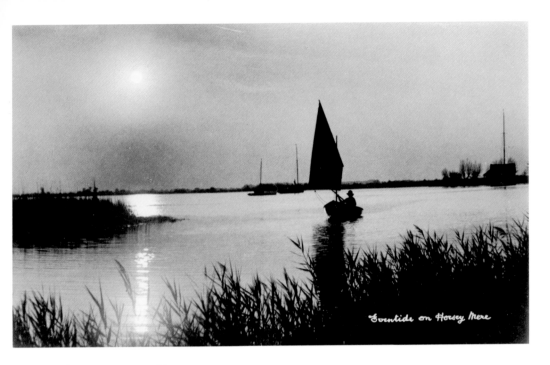

Sundown on Horsey Mere

The early picture shows the sunset of a summer evening, from around 1936, and the other photograph is a winter sunset from 6 January 2009. Horsey Mere is a wild, evocative place, home to all the special and rare creatures of the Broads. It even nurtures a colony of wild cranes, which appeared in the early 1980s and have since established a breeding population.

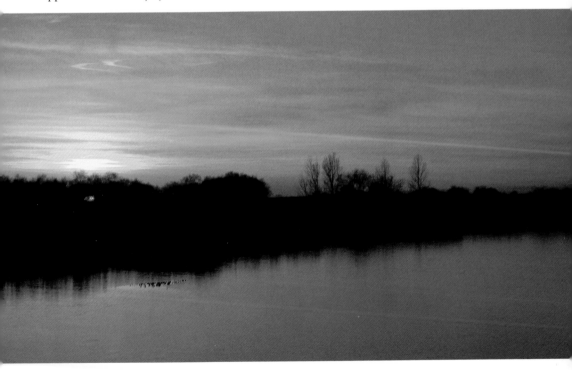

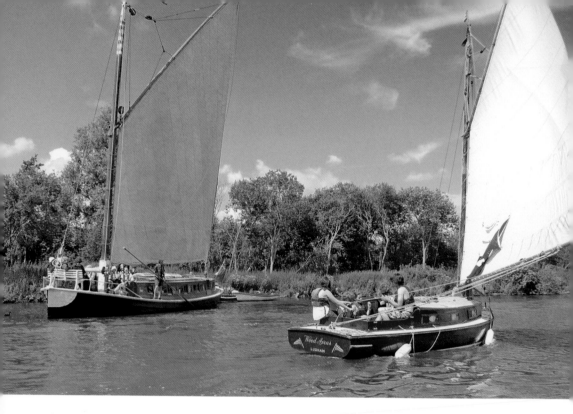

River Traffic, July 2008, South Walsham
A yacht from the Heritage Fleet, *Wood Avens*, built in 1949, speeds past the *Hathor*, built in 1905, under sail but needing the gentle assistance of a shove with the quant pole.

Acknowledgements

The majority of the old photographs in this book come from my own collection, but there are a few exceptions. Those on pages 74 and 85 are from the Boardman family albums, for which my thanks go to Mrs Shirley Place and Peter Boardman. The picture of wherryman William Royall was kindly lent by my good friend R. W. Malster.

All the colour photographs are my own, the majority being taken specifically for this book. However, I am delighted to thank Peter Bower for his willingness to pose for the picture on page 37. Sam the dog actually belongs to Peter's colleague and friend Richard Jones, but Sam has spent much of summer 2009 on board the *Hathor*. I am also grateful to Eric Edwards, MBE, for his kind assistance, and for lending me 'Blucher' Thain's boots.

As always, I am very much indebted to my wife Sue for typing the scribbled manuscript, as well as for constant encouragement.

If your favourite Broads view is missing, I am sorry, but it probably means I don't have a black and white photograph. I am always looking for more . . .